Eye on the West Photography and the Contemporary West

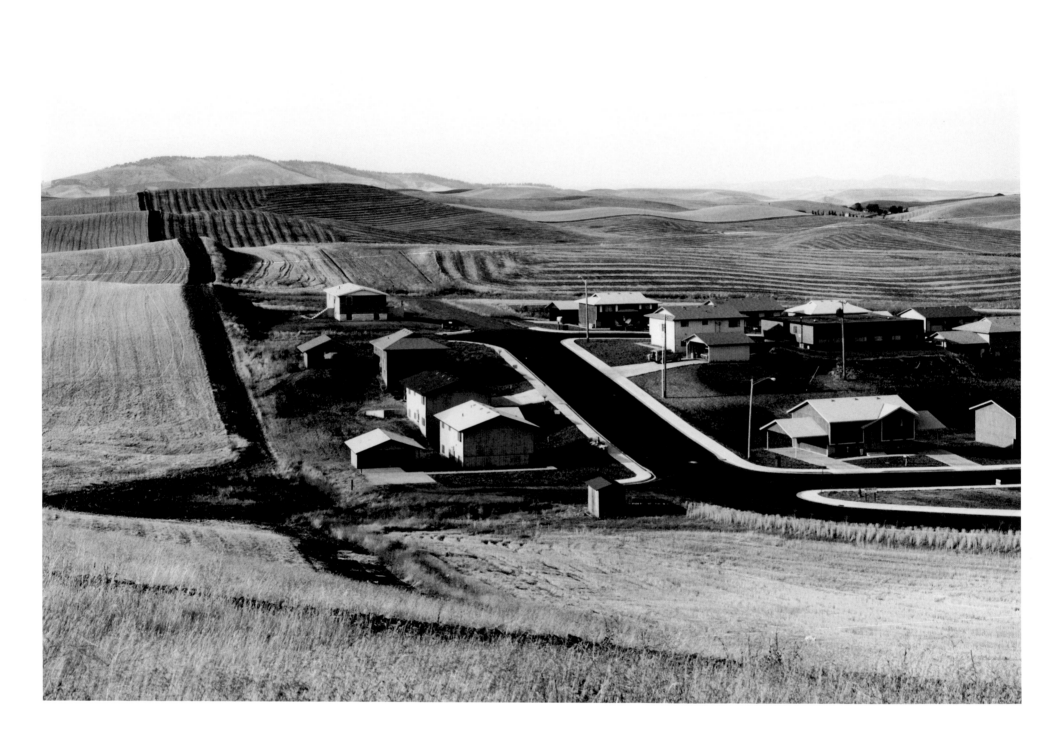

Eye on the West Photography and the Contemporary West

George Miles

with contributions from
Abe Aronow
Marion Belanger
Richard Buswell
Miguel Gandert
Karen Halverson
Lauren Henkin
Jon Lewis
Owen Luck
Laura McPhee
David Grant Noble
David Ottenstein
David Plowden
Roberta Price
Kim Stringfellow
Toba Pato Tucker
John Willis
Will Wilson

The Beinecke Rare Book & Manuscript Library, Yale University
Distributed by Yale University Press, New Haven and London

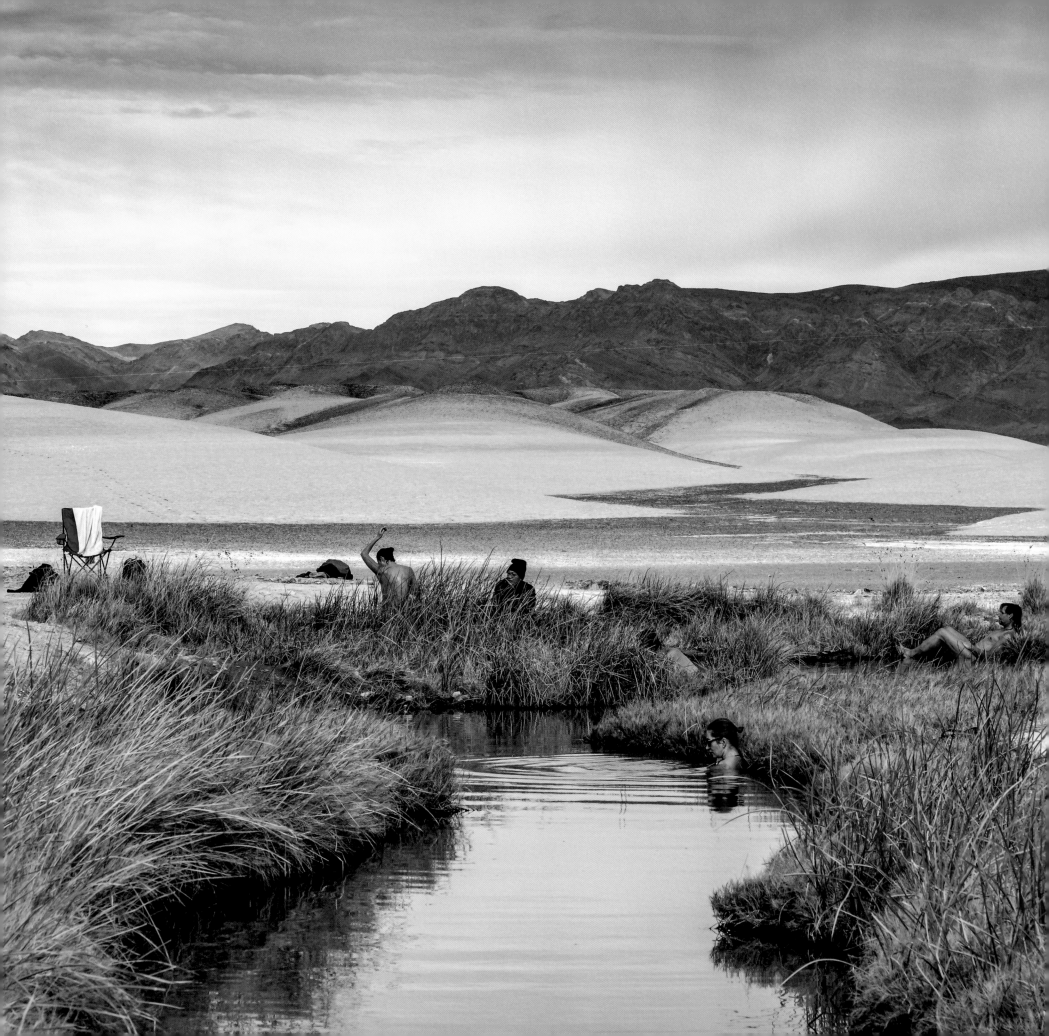

CONTENTS

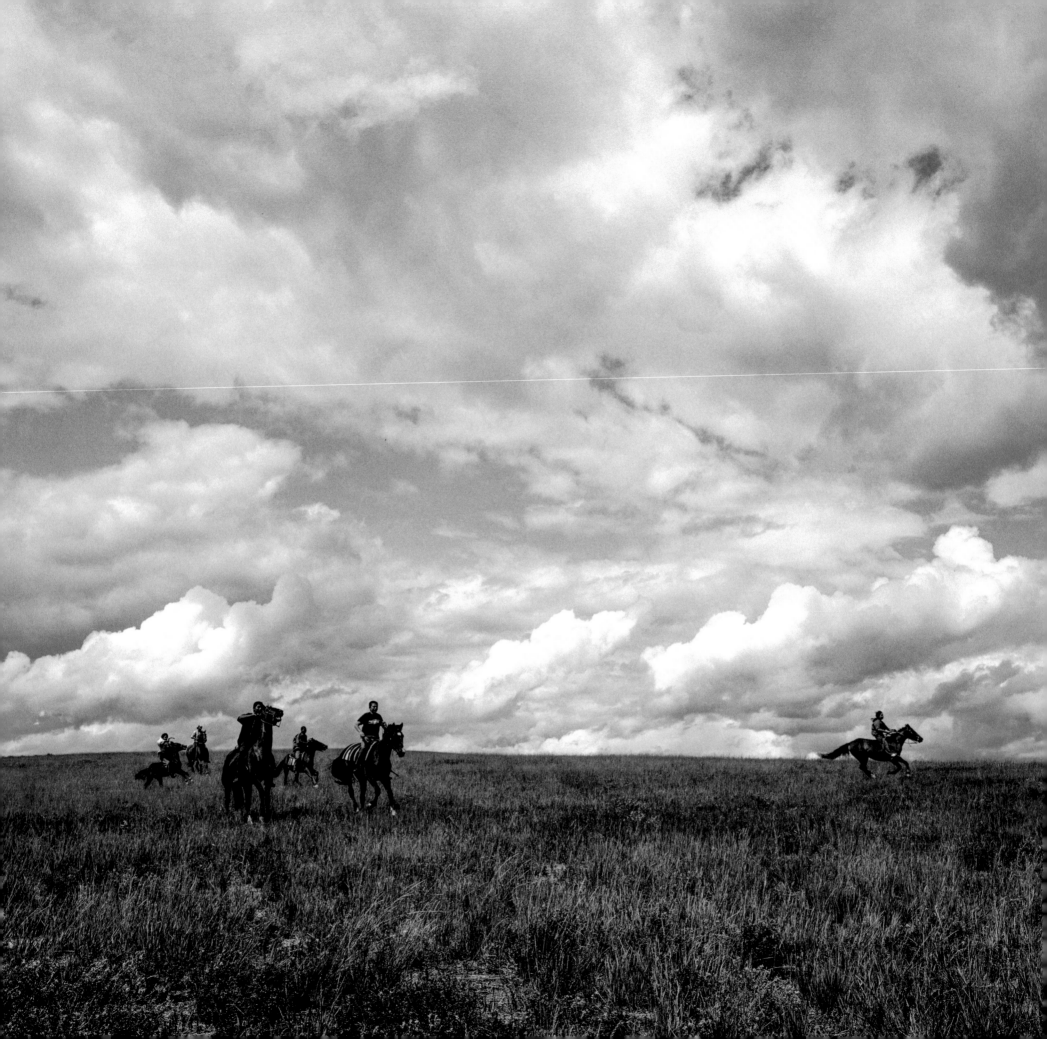

Director's Foreword

The Beinecke Rare Book & Manuscript Library aims to excite scholars and the public to engage with the past, in the present, for the future, by collecting and making available materials that document human experience across millennial and geographic boundaries. The library is the custodian of numerous cultural treasures, including more than one million books and countless millions of manuscript pages.

Perhaps less widely recognized, it is also home to one of the most significant collections of photography in any museum or library. We recognize photography as an absolutely critical medium for understanding human culture over the past two centuries through to our present day.

Western Americana is one of the areas of greatest strength in the Beinecke Library and one where photography is at its strongest. This book, and the exhibition it accompanies, by George Miles, the William Robertson Coe Curator of Western Americana, embodies the conjoined strengths of Western Americana and photography. *Eye on the West*, I believe, represents the Beinecke Library at its best.

The same is true of George: he exemplifies the best of what special collections do in service of the university and society. He is esteemed for his collaborative spirit and creative excellence by his colleagues in the library, by the faculty and students at Yale, by professional colleagues beyond our campus, and by countless public visitors. They all have been inspired by his dynamic scholarship, his enthusiasm for the field and its people, and his extraordinary passion for making the collections accessible in the reading room and classrooms, in exhibitions, in print, and online.

James T. Babb, a former Yale University Librarian, liked to say that the Library not only collected collections, it collected collectors. George and his contemporary curators have continued that legacy and expanded on it: they collect creators. This book brings into focus the essential efforts of the curator with living authors and artists to develop in-depth archives that document and honor their work for current and future generations to contemplate.

Eye on The West is a fitting and, dare I say, glorious, invitation to audiences both academic and public for the archives at the Beinecke Library: come look for yourself.

Edwin C. Schroeder
Director
Beinecke Rare Book & Manuscript Library

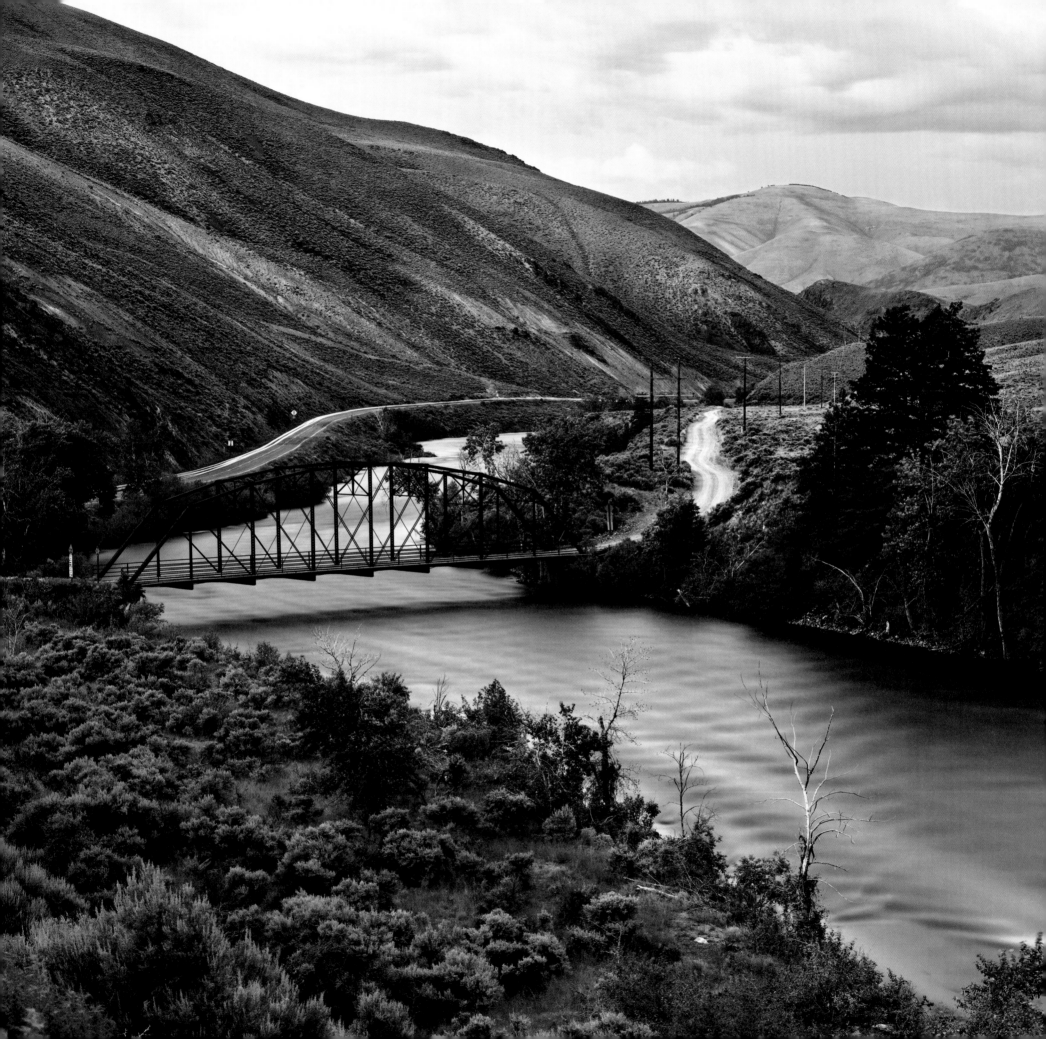

Windows on an Ever-disappearing World

George Miles

The photographs in this book are all drawn from the Yale Collection of Western Americana at the Beinecke Rare Book & Manuscript Library. It may surprise some that the collection contains tens of thousands of photographs, including many from the late twentieth and early twenty-first centuries. Photography is an art and craft we usually associate with museums, something to be seen framed on gallery walls rather than on tables in the reading rooms of research libraries. But the history of photography in the United States and the history of the North American West have been so intertwined that no collection which seeks to document the history and culture of Native American communities as well as the global migrations that have transformed the North-American West since 1492 can ignore the medium.

Photography came to America in the 1840s, the same decade in which the annexation of Texas, the Mexican War, the Oregon Treaty, and the California Gold Rush transformed the West. As the federal government and citizens of the United States asserted new authority over large parts of the continent, pioneer photographers accompanied Zachary Taylor's army to Mexico, gold seekers to California, and government survey teams to the Rocky Mountains. They set up studios not only in the booming metropolis of San Francisco but also in the small rural towns of Iowa. They sold their pictures to local residents to hold in their homes but also sent them to the nation's capital to inform discussions in Congress and the Cabinet. Exhibited in studios and galleries in Eastern and European cities, distributed in books, and mounted on cards, photographs shaped the ways that American and European popular culture perceived the people and places of the Trans-Mississippi West.

At the same time as photography was influencing public policy and culture, the ways in which the West was being transformed shaped early American photography. Investors in railroads, mines, and western lands joined government scientists as patrons of extended projects in large-format landscape photography that would help confirm their verbal descriptions of western resources. A widespread desire of Americans to imagine a trip on the transcontinental railroad, a visit to Yellowstone National Park, or a tour of wealthy homes overlooking the Golden Gate contributed to the emergence of serial photography, including the publication of boxed sets of stereoviews that provided remote audiences a three-dimensional experience of western wonders. The opportunities and demands created by western expansion contributed to photography's development as a medium of record as well as a form of creative expression.

Although the United States changed dramatically between 1840 and 1940, American photography continued to find the West a place of interest. The Works Progress Administration replaced the Geological Survey as a key federal sponsor of photography; the WPA's collaboration with more than a dozen photographers created an enduring record of the rural West during the Great Depression. Private patrons of photography such as the Union Pacific Railroad or Leland Stanford faded away, but *LIFE, Fortune,* and other illustrated magazines, as well as non-profit organizations like the Sierra Club, underwrote the creation of a large body of work that depicted the costs and benefits of industrial, urban, and residential development in the West. Independent stereoscopic photography succumbed to international syndicates and the Disney-themed View-Master, but inexpensive photobooks emerged as a means by which photographers could distribute their images to a wide public audience.

In the last half-century, the period with which this volume is concerned, new patterns have emerged for supporting and distributing photography of the West. Federal executive agencies no longer sponsor major photography projects, but the National Endowment for the Arts and the National Endowment for the Humanities have become channels of government support. Buffeted by political controversies, both the NEA and NEH have distributed money and decision-making to state and local arts boards who have stimulated the development of geographically focused projects, many of which have explored western communities or issues. The transformation in the government's role from immediately employing photographers to indirectly sponsoring them has been mirrored in the private realm. A precipitous decline in popular illustrated magazines has been offset by the emergence of foundations as powerful patrons of photography. While the diverse missions of contemporary American foundations support a wide range of photographic projects exploring Western topics, the foundations' interests have shaped the themes, subjects, and expressive modes of those projects every bit as much as corporate

sponsors did after the Civil War. At the same time, museums and research libraries have begun to emerge as important patrons of Western photography. Before 1970, few American museums or libraries had embraced the mission of developing and curating photography collections. Over the last fifty years, one after another of the country's major cultural institutions have established photography departments. The curators of those newly established collections have spent much time acquiring historical collections, and it is clear that they have also become a significant component of the contemporary photography market. The decisions they make about which photographs to add to their holdings not only validate existing work but influence what new photographs will be made.

The history of photography in the Yale Collection of Western Americana resembles the national pattern. The collection was created in the 1940s in response to the donation of William Robertson Coe's extraordinary personal library of rare books, manuscripts, and art that documented American expansion west of the Mississippi River. Mr. Coe held important photo albums of Yellowstone by William Henry Jackson and Frank Jay Haynes as well as an extensive collection of A.J. Russell's photographs of the construction of the Union Pacific Railroad. The gift spurred the Yale University Library to review its holdings and transfer materials like Mr. Coe's to the newly created special collection. The transfers included dozens of Alexander Gardner's portraits of Native American diplomats that Yale professor Othniel C. Marsh had donated to the library in the nineteenth century. Other faculty members and Yale graduates such as James Dwight Dana, Frank Bradley, Arthur Brewer, Alphonso Taft, and Gifford Pinchot had donated photographs by Timothy O'Sullivan, Carleton Watkins, and Edward Curtis. Shortly before the Western Americana Collection opened for research in 1952, Yale alumnus Walter McClintock, who had spent over a decade at the turn of the century photographing the Blackfeet Indians of Montana, donated his photographic archive.

In the three decades after it opened, the collection made several important acquisitions of nineteenth-century Western photographs including a set of daguerreotypes of scenes from the Mexican War and a portfolio of Carleton Watkins's mammoth plate photographs of Yosemite. The pace of acquisitions quickened in the 1980s, significantly expanding the collection's holdings not only of government sponsored survey photography, but also of Western studio photographs, images made by hundreds of pioneer photographers who opened businesses across the West. The acquisition of two private collections, the Peter Palmquist Collection and the Victor and Lori Shephard Germack Collection, established the Yale Collection of Western Americana as one of the country's leading repositories of nineteenth-century Western photographs.

The collection did not begin to collect photography of the contemporary West until 1995 when it acquired 1,000 exhibition prints and more than 3,000 work prints

documenting the career of Yale alumnus David Plowden. The Beinecke Library's agreement with Plowden also included plans for his negatives and contact sheets to come to the library when he was finished using them. The acquisition of David Plowden's photographic archive established a model for the Western Americana Collection's efforts to acquire contemporary work. Whereas many museums and galleries strive to build a collection of masterworks that represents the breadth of work being done in the West, the Western Americana Collection has focused on documenting in depth the work of a limited number of photographers. Typically, the library has acquired several hundred prints from each photographer it has collected; it has also made commitments to preserve the photographic archive of several individuals. This book seeks to expose seventeen major acquisitions that the collection has made since the mid-1990s.

The emergence of arts organizations and cultural-heritage institutions like the Beinecke Library as significant patrons of contemporary photography, as well as the increased role that artists and critics have come to play on the award panels of leading foundations, has made judgments about contemporary photography more reflexive, engaged with the history of the medium as well as the immediate qualities of a particular image or photographic project. Well into the twentieth century photography enjoyed the benefits and suffered the costs of its shallow history. The lack of a canon against which to compare and evaluate new work liberated photographers but also left them without traditions to work with or against. By the 1930s, as photography approached its centennial, artists and critics such as Alfred Stieglitz and Edward Steichen began to define its history and its canonical images, but that process moved forward slowly until the 1970s when multiple institutions began to emulate the program that Steichen and John Szarkowski established at New York's Museum of Modern Art. Since then, an outpouring of exhibitions and monographs, as well as the proliferation of academic photography programs, have transformed the way that scholars, curators, and photographers think about the medium and about new work.

The anxiety of influence weighs heavily upon photographers of the contemporary West. All artists, literary or visual, confront the challenge of finding original insight or expression amid the work of their predecessors. Photographers working in the West today must navigate between the masterworks of photographers including Carleton Watkins, Timothy O'Sullivan, Ansel Adams, and Edward Weston and the popular, if often inaccurate, iconography of the West created by Hollywood, television, and the advertising industry. To create distinctive work for an audience saturated with images of "the West," past and present, they must simultaneously grapple with popular nostalgia for an imagined past and the extraordinary corpus of outstanding work compiled by those who came before them. To create a portfolio of images that makes us look anew at the West, to see what is distinctive about it today, requires a mix of courage and patience, of imagination and persistence.

Among the issues confronting contemporary photographers (and curators) is the question of whether "West" remains a useful frame of reference. In an increasingly global economy marked by the dominance of mass-media, chain stores, and social networking, do the communities and landscapes of the North American West present distinctive stories or embody particular issues that enhance our understanding of American history and culture? The seventeen photographers whose images appear in this book have responded in various ways to this question and to the challenge of making original work about the West.

Jon Lewis, Roberta Price, and Owen Luck used their cameras to document social movements that arose from and transformed Western economic, cultural, and political structures. All three participated in the movements they recorded: Lewis, the creation of the United Farm Workers; Price, the blossoming of a rural counterculture in northern New Mexico and southern Colorado; Luck, the rise of the American Indian Movement and, more recently, as an observer, the cultural renaissance that has flourished among indigenous communities of the Pacific Northwest.

Other photographers have created visual records of their immediate communities and homelands. The photographs of Richard Buswell, from Helena, Montana, and David Grant Noble, from Santa Fe, New Mexico, explore and reanimate the deep history of the regions in which they live. The abandoned sites and discarded objects they depict seem both unfathomable and oddly familiar, distant but approachable. Miguel Gandert, from Albuquerque, portrays the enduring vitality of traditional Indo-Hispano culture in contemporary New Mexico. Abe Aronow, from San Francisco, and Kim Stringfellow, from Southern California, contemplate contemporary ways of living in the West. Aronow's candid portraits wryly comment on the eccentricities of San Francisco's residents, while gently celebrating its rich diversity. Stringfellow's images examine the many ways Americans have tried, and often failed, to live amid the austere beauty of the Mojave Desert.

Sometimes it is a visitor who most clearly perceives the defining characteristics of a community. Although they were raised in the Northeast, David Plowden and David Ottenstein have focused their cameras on the inexorable transformation of the West's agricultural heartland, trying at once to convey what was, what is, and what is to come among the small towns and family farms of America's prairies and plains. The challenge of sustaining community in the contemporary West also interests John Willis who has spent nearly a quarter-century visiting among and learning from the Lakota people. Willis's images, which spiral outward from intimate family portraits, to community gatherings, to the reservation landscape and the non-Indian communities that surround it, present the vitality of the Lakota people as well the challenges they confront.

Will Wilson and Toba Tucker have deliberately engaged historic photographic projects to draw attention to what is ephemeral and what endures in the West and

in its people. They provoke us to consider the legacy of earlier projects, the way older images can distort our thinking about the contemporary West, and how the people and places of the West have changed for better and for worse. Wilson's portraits of Native Americans challenge the cultural hegemony of Edward Curtis's work. Tucker once moved to Heber Springs, Arkansas, for two years to record how the townspeople had changed since Mike Disfarmer portrayed them in the early 1940s. More recently, she has undertaken to reframe scenes that William Henry Jackson and his colleagues embedded in American popular culture.

Traveling through the West, Lauren Henkin and Marion Belanger find it ripe with visual metaphors that illuminate the cavalier disregard we often exhibit toward nature's power and our careless treatment of its abundance. In contrast to the monumental landscapes of Watkins, Jackson, and Ansel Adams, their images suggest the fragility of our presence on the land. The intersection of human and natural histories is also a major interest of Laura McPhee and Karen Halverson. Their expansive color images explore the many ways contemporary Americans inhabit and transform landscapes shaped over millennia by wind, rain, fire, and tectonic upheaval.

Despite their distinctive projects and diverse tools, the photographers represented here all work within a documentary tradition that has been a major aspect of Western photography since the nineteenth century. They make photographs to share with others what they have seen, or perhaps more directly, what the world looks like to them. Their work is rooted in specificity, anchored in the concrete. They present to us opportunities to see a particular person, place, or event outside our usual field of vision, to see something we have overlooked, or, perhaps, to see differently a scene we have looked at without comprehension. They do not copy the world; they create an intervention that stands between us and the world, an intervention that encourages us to see, feel, and think differently about the world than we did before we looked at the image they have created.

It is ironic, in a book of selected images, to acknowledge that the works of its contributors, even at their most powerful, are best understood as parts of their larger projects. Like poems in a volume or songs in an album, their photographs are meant to be encountered in sequence, their meanings enhanced or qualified by images seen before or after. As in any sequence, an individual photograph may come to stand for the whole, to epitomize a project or the artistic accomplishments of its maker, but outstanding documentary photography consists less in making a single powerful image than in the creation of a body of work that compels an audience to connect individual images and see how pieces come together to present a larger, more complex, more nuanced "view" than any one picture can.

The photographers of this book recognize the power of association; among them they have published more than seventy-five photobooks in which they present

their images in sequences they designed to shape how readers experience them. For this book, however, they have collaborated with the editor to select the photographs and provide brief essays about each picture. Except for Jon Lewis, who passed in 2009, each photographer selected one of their own photographs, about which they wrote. The editor chose a second picture, about which he has written. The responsibility for arranging the images fell to the editor. His arrangement is meant to encourage readers to consider how the work of different artists speaks to others, to suggest that our understanding of the individual images, and of the artists who made them, is enhanced if we see them not only as part of a single artist's body of work but also as part of a national project of looking at the American West, of considering how it remains a distinctive place, inhabited by people whose personal stories are embedded in its rich history.

This volume does not seek to propose a grand narrative about the contemporary West or American photography so much as it strives to encourage contemplation and inquiry. The images shown here were selected from Beinecke Library's collection of more than 7,500 photographs made by the seventeen photographers. The library has built that extensive collection to support research by artists, students, and scholars seeking to examine not just a masterwork, but the project from which it emerged as well as the creative process behind it.

The earliest photographs reproduced here are from 1966; the most recent were made in 2016. Spread across fifty years, the pictures reflect the changing nature of photographic capture and printmaking. The equipment used to make the photographs ranges from compact 35mm cameras using rolled black-and-white film through bulky view cameras (the largest of which holds a single 8 x 10 sheet of color film) to various digital SLRs whose sensors can capture images in monochrome or in more than 16 million colors. The original photographs include tintypes, silver-gelatin prints, chromogenic color prints, and a variety of pigmented-ink prints made from digital files, some of which were created by scanning film negatives and others that were created directly by digital cameras. All the original photographs are available to be examined in the Beinecke Library's reading room.

For several of the seventeen photographers, the library has collected negatives, contact sheets, and work prints as well as exhibition prints. They reveal the evolution of a photographer's eye and technique—in the field, in the darkroom, in a digital editing program. Sometimes they preserve the "too hot" and "too cold" images that bracketed the "just right" exhibition print. Sometimes, those negatives and contact sheets preserve an imperfect photograph that an artist declined to print but that nonetheless conveys unique information about what the West looked like a particular time and place. The library holds them in the conviction that photography provides an essential, if imperfect window on an ever-disappearing world.

If you like what you see here, please come to the Beinecke Library to explore the original collections.

Abe Aronow *Ansel Adams,* Carmel, California, 1983

This portrait of Ansel Adams was made at his home in Carmel, California, on June 21, 1983. The occasion was a reunion of Group f/64, a collective of mostly West Coast practitioners of serious art photography, who agreed on an aesthetic of sharp-focused "straight" images in reaction to the then-prevailing photographic wisdom. A short time before the gathering at his home, Adams left a message on my professional answering service for me to call him. When I returned his call, he asked if I wanted to come down to Carmel to participate in a circus. In clarification, he explained that the surviving members of the Group (Ansel and Willard Van Dyke) were meeting a number of important people at Ansel's home, with the purpose of filming a documentary. The assembled crowd was a "who's who" of serious Western photography. I accepted his invitation and attended, joining others in a daisy chain of mutual portrait-making. My long-term project, making photo-portraits of people involved in photography, started on that day.

I had first met Adams in 1981, when I was asked to see him during a stay in hospital. After he was discharged, he and his wife, Virginia, invited me and my wife, Alice, to their home. There, he showed us many of his treasures, including the large black ceramic sculpture in this picture. He had acquired it from the artist Juan Hamilton, a close friend of Ansel's long-time friend, Georgia O'Keefe (her image can be seen in the far left of this print). Ansel kept the sculpture on his piano top and was fond of turning it to show how the light and reflections of the wall-hung prints played on its glossy surface. We went home and decided to make him a turntable on which he might more easily rotate this piece. We turned on a lathe a piece of hardwood that we had found in Guatemala and presented it to him soon after our visit. By the time of the reunion, the sculpture was reposing on it, as seen in the picture.

Among his many accomplishments, Adams was a well-trained pianist. He might easily have made that his primary profession. In later life his hands were quite arthritic and the condition impeded his playing, but music was inherent in his vocabulary. He used musical metaphors in describing tonality and light in photographic images and the process of making the negative, which he called the musical score, and the print, the performance. He led the movement to introduce rigor to the photographic process. Each new printing session from an older negative might yield a slightly different interpretation. He described some of his later-life prints as having evolved in a dramatic "Wagnerian" sense. He was one of the first to emphasize and to teach the concept of "pre-visualizing" the scene before his lens as it might appear in the final print.

Ansel was a very generous teacher and a prolific writer who mentored many rising photographers. He wrote two multi-volume book sets outlining the black-and-white-photographic process; these texts established professional standards for art photography and the production of high quality, archivally stable prints. His many photographic books were marvels of precise printing and aesthetic beauty.

He was an early and determined leader in environmental causes, especially in the American West, often using his photo-graphy to enhance his advocacy. His prints of U.S. National Parks, monuments, and wilderness areas were a unique force for their preservation. He was a long-term member of the Sierra Club and had close friendships with many of the stars of the environmental movement.

Ansel Adams was one of the most important lovers of the American West and one of my heroes.

A. A.

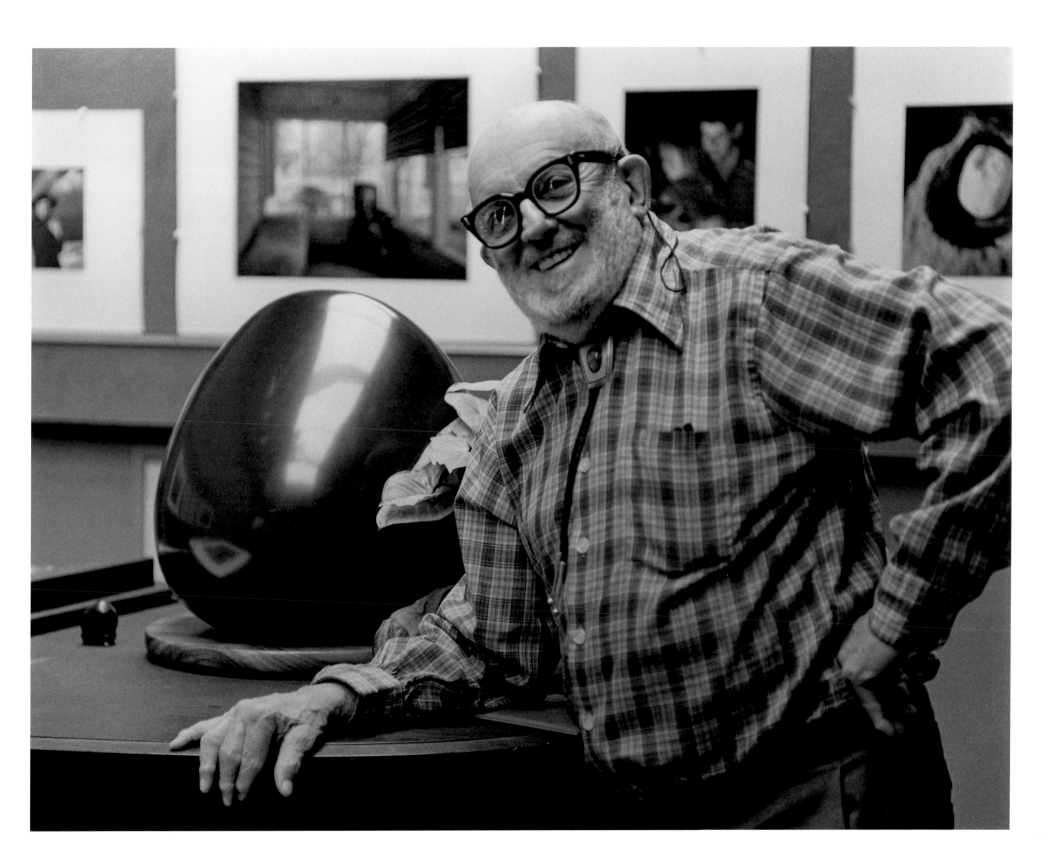

Will Wilson *Kevin Gover. Citizen of the Pawnee and Comanche Nations; Director, National Museum of the American Indian,* 2012

Literary artists routinely revisit classical stories, adapting ancient themes and plots to create new works which help us appreciate what endures and what is mutable. In contrast, photography has been an art which embraces change and innovation. From its earliest days, photographers have tweaked the process, changing chemicals, papers, cameras, and lenses to make more, better, less-expensive images. But as the medium approaches the bicentennial of its invention, more and more photographers have begun to explore ways in which older technologies and conventions might be invoked, not as a sentimental celebration, but as a tool to challenge our creative imagination.

Diné photographer Will Wilson could have used a high-resolution digital camera to capture a color portrait of Kevin Gover. Instead he made a tintype: a direct, monochrome positive on a thin piece of japanned iron. Devised in England as an inexpensive alternative to the daguerreotype, the process came to the United States in the mid-1850s. It flourished for a quarter century and lingered as a novelty into the twentieth century.

The surface of the tintype was prepared just a few minutes before exposure; to be sensitive to light the emulsion had to remain tacky. Uneven applications of the emulsion were common, especially at the corners of the plate. Photographers often relied on oval mats to hide the streaks and voids that frequently occurred. As each exposure produced only a single positive, most tintypes were personal portraits made for their subject or a relative. Wilson extends this tradition by giving the tintype he makes to his subject, but first he scans the plate, creating a digital file from which he makes multiple pigmented-ink prints.

Wilson's portrait is elegant and strange. Its subtle, warm tones, and fine detail are familiar and alluring, but its mottled gray background is incongruous. So too are the streaks and blurs across the foreground. Mr. Gover's wire-rim glasses and the button-down collar of his shirt assert that this is a contemporary portrait, but the image seems to be from a different time. It evokes memories of nineteenth-century portraits we have seen in libraries, museums, or our grandparents' scrapbooks. It encourages us to contemplate Gover, not merely as our contemporary, but as a figure who transcends time.

How we respond to the dissonant aspects of Wilson's portrait depends a great deal on our imagination. To comprehend it and its implications, we must pause and reconsider what we know. Might a photographic technology which leads us to conceive of Gover as from another time spur us to re-imagine the subjects of nineteenth-century portraits? Could it stimulate our empathy and help us overcome the distance created by both the passage of time, and changing technology and aesthetic standards? Can we see through the quaint surface of those nineteenth-century portraits and regard their subjects not as distant figures, but as people who resemble us more closely than we had thought?

G.M.

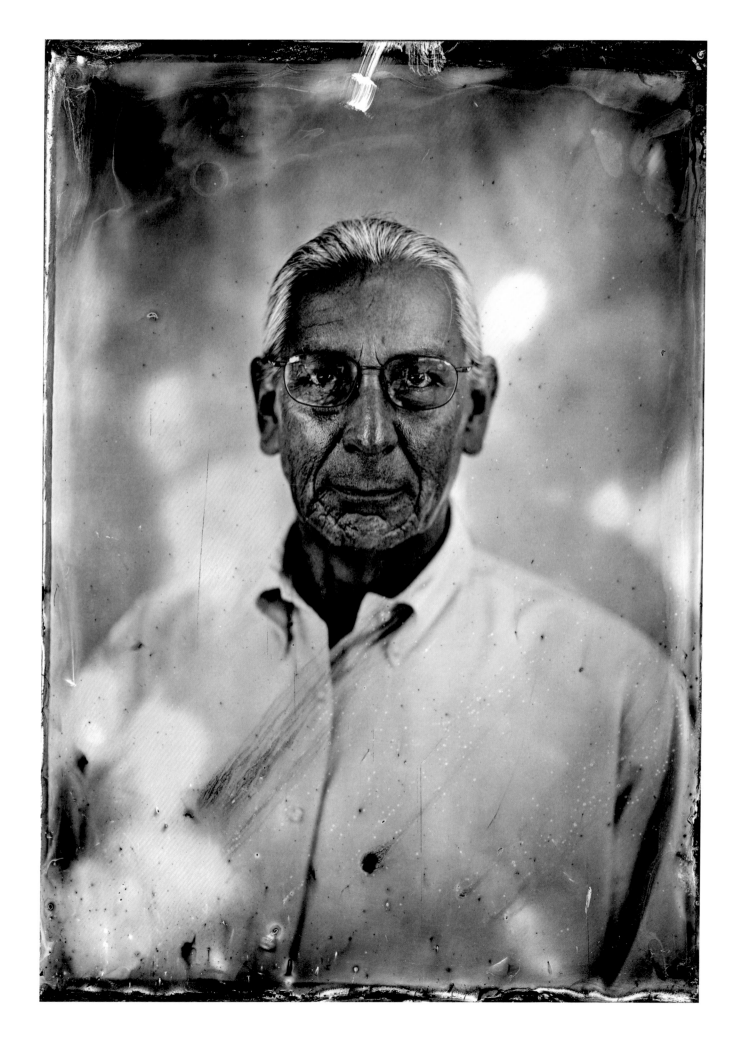

David Grant Noble *The Runner,* Galisteo Basin, New Mexico, 1988

I discovered this figure chipped in stone more than forty years ago while exploring an extensive collection of rock art in New Mexico's Galisteo Basin. It is a sacred place, a place of spirits, and history, and certainly of beauty.

The petroglyphs are along San Cristobal Creek, which flows off a mesa past the crumbling remains of a large Indian pueblo. Centuries ago, the village's Southern Tewa inhabitants marked the mesa cliffs with thousands of images pecked on the rock surfaces with stone hammers and chisels. More than three hundred years ago, the people moved away and, as time passed, the roofs of their homes collapsed upon each other eventually forming mounds overgrown with native grasses, saltbush, and cholla cactus. From the cliff, you have a view down on the mounds and plaza depressions and across the valley to Cerro Pelón and farther still to the distant Jemez and Sangre de Cristo mountains. On summer afternoons, thunderheads rise over the highlands bringing promise of rain.

Today we text. Even email is passé. Writing on paper, a rarity. To chisel words or pictures into stone, well, that takes time, effort, and careful reflection. It is no jotting down of passing thoughts. You have to be certain what you want to say, and say it right the first time, for it will last centuries, perhaps millennia, and be seen or read by people in a far-distant future. We should not take lightly what someone has inscribed in stone.

As to this running figure, there's a story—at least I have a story. In 1680, when the Pueblo Indians of New Mexico were making final preparations to rise up against their Spanish overlords, they dispatched runners to all the villages to announce the day the revolt would break out. According to legend, as each messenger hurried from pueblo to pueblo, he carried with him a knotted cord and untied one knot each day until none was left. On that day, August 12th, all hell broke loose. To me, in this picture, we see the courier.

Many times over the years I visited this place along San Cristobal Creek, to be there, but also to make pictures and especially to photograph this running man. Successful photography, as we know, depends on good light, and each time I went there the light was not right—too flat, too glaring, or the shadows too deep. Then one day my luck changed. I remember, it was a late afternoon in September of 1988 and smoke from Yellowstone's great wildfire had drifted over New Mexico muting the sun's intensity. The grasses were blooming, too, and the cliff formed a protective arch over the runner. It was a gift and I was there to receive it.

Of course, I do not know what the petroglyph maker had in mind when he or she pecked this image in the cliff. But it has special significance to me. Do you see the runner has strength and vitality? And sense of purpose? These are qualities we all strive for. And then there's the mystery of his destination—that's an uncertainty we all deal with.

It was late summer when I made this picture; the sun was warm in the afternoon and the light was strong. Now, in the late autumn of my life, I'm thinking, perhaps I should go back and photograph it again, in winter.

D.G.N.

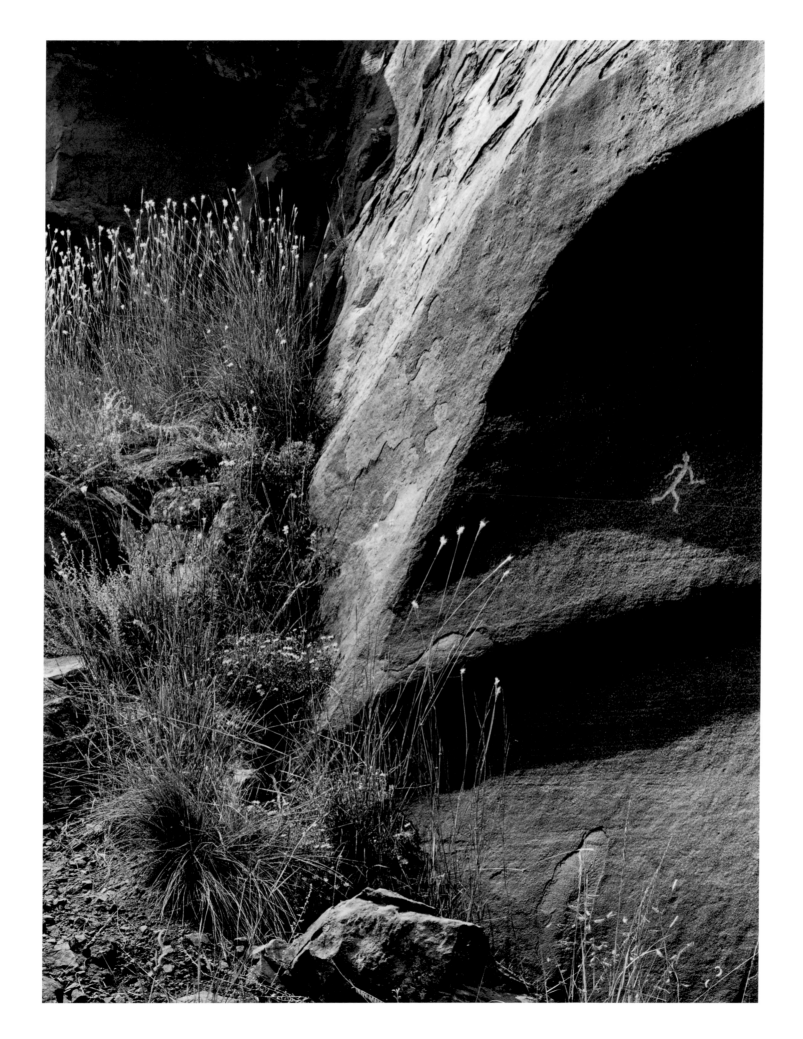

David Plowden *Carter, Montana,* 1971

An unpaved road, bordered by parallel lines of utility poles guides our eyes toward the open plains that lie south of Carter, Montana, a small town north of the Missouri River, roughly one-third of the way from Fort Benton to Great Falls along U.S. Route 87. But the true road out of Carter doesn't run north and south through David Plowden's photograph; instead it runs east and west across the plane of the picture. Plowden composed his image so that the luminous General Mills grain elevator diverts our eye from the road and draws our attention to the Great Northern railroad car being loaded with wheat from Montana's "Golden Triangle." As tourists in a car, we might enjoy driving to the banks of the Missouri, but local farmers would know that their economic and cultural lifeline was the twin-railed tracks of the Great Northern that enabled them to send their grain to mills and markets thousands of miles away.

As the cathedral was to medieval Europe, so the grain elevator was to the American Great Plains: a majestic architectural triumph that marked and towered over village life. Unlike the cathedral, which stood by itself, the grain elevator signified the presence of an even more important institution, a railroad depot which, no matter how humble its appearance, provided a commercial impetus for people to gather.

The farmers of the Great Plains have always had a complicated relationship with railroads and millers. Without the infrastructure of tracks and grain elevators to transport and process grain for sale across the world, the commercial agriculture of

Montana and other western states would wither; the local market could not consume a fraction of the region's productive capacity. But no single farmer—not even when he joined with his immediate neighbors—could damage the railroad or the mills by withholding his grain. The power of the railroad was reflected in its decision in 1905 to change the name of its depot from Sidney, the original name of the settlement, to Carter, to curry favor with Montana's first congressman, Thomas Carter. So it was that institutions of local pride and essential purpose could also become a focus of resentment.

For a century and a half, the history of North America's Great Plains has been the advance and transformation of commercial agriculture. Promotional efforts by railroads like the Great Northern brought tens of thousands of settlers to the Far West in the decades after the Civil War, but the population of many western counties peaked a century ago. In 1910, Chouteau County, Montana, which includes Carter, had 17,191 residents. By 1970, the year before Plowden visited Carter, the census recorded 6,454 residents in the entire county. By 2010, the county number had declined to 5,813 residents and Carter's total population was listed at 58.

Despite the decline in total numbers, Chouteau County remains one of the most productive wheat-growing regions in the United States. Carter maintains an elementary school, a post office, and a Methodist Church. Most important, it features three active grain elevators and a refurbished railroad office.

G.M.

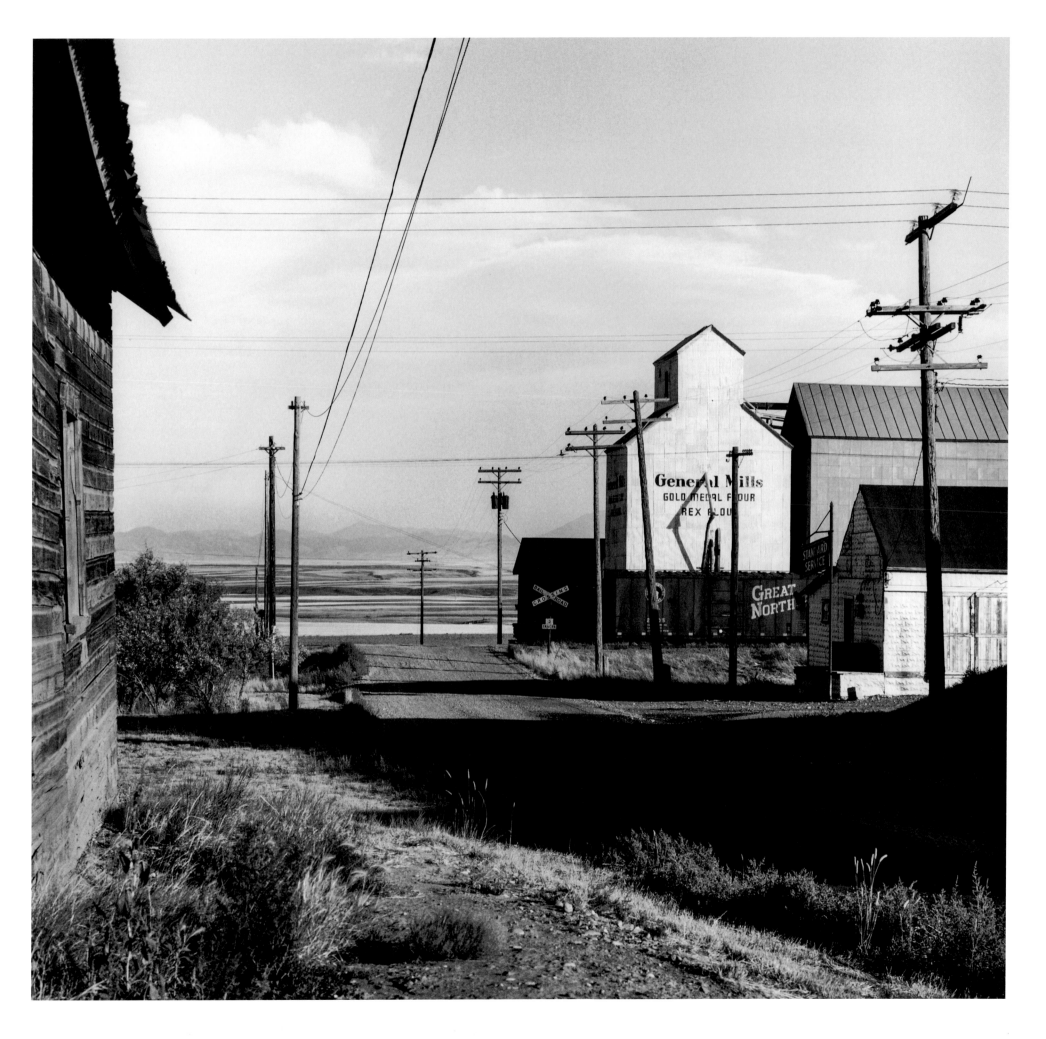

Laura McPhee *Salmon River Bridge,* Clayton, Idaho, 2011

When we try to pick out anything by itself, we find it hitched to everything else in the Universe.

John Muir, *My First Summer in the Sierra,* 1911

Reflecting on the intricacies of place and the records made by time, both geologic and human, and on the interconnectedness of things—natural, political, personal—have been the driving forces of my work. Photographs, though they record the present moment, harbor visual clues to the past and intimations of the future.

Roads old and new transect a landscape. The old dirt road might well have been traveled by my great-grandmother—a single mother and roving schoolteacher—and her two daughters as they passed from Montana westward to Idaho. They could have been riding horses, or walking, or in a coach or car, depending on the year and the economic situation in which they found themselves. They may have stopped in the mining town of Crystal before crossing a bridge over the Salmon River. If they arrived before the Depression, the bridge was made of wood. Replaced in the 1930s, it is now a trestle bridge of steel. It will not be replaced again. Downstream a concrete bridge now spans the Salmon, and Crystal, which the old bridge served, was almost perfectly erased from the land half a century ago.

The new road runs along the Salmon River, bisecting Custer County, a mountainous terrain almost half the size of Massachusetts with a sinking population of just over 4,000 people. The only traffic light graces the facade of a small town bar and indicates whether liquor is available on the other side of the door. The Salmon River itself remains apparently unchanged, but the salmon that once turned up annually in multitudes have dwindled to the point of near-extinction, due to the combined effects of water diversions for ranching and mining, downstream dams, and climate change.

With little pressure from humans, wilderness of the highest quality nearly embraces both sides of this road. Moose, deer, elk, American pronghorn, wolves, coyotes, bears, sage grouse, salmon, chukar, owls, rattlesnakes, rubber boas, pygmy rabbits, cottontails, snowshoe hares, black-tailed and white-tailed jackrabbits, yellow-bellied marmots, bald and golden eagles, bobcats, and mountain lions all live in this sagebrush-steppe habitat, vastly outnumbering the humans who come in summer hoping to see them. As for citizens of Custer County, there is one per square mile. The night skies are among the darkest anywhere on Earth.

L.McPh.

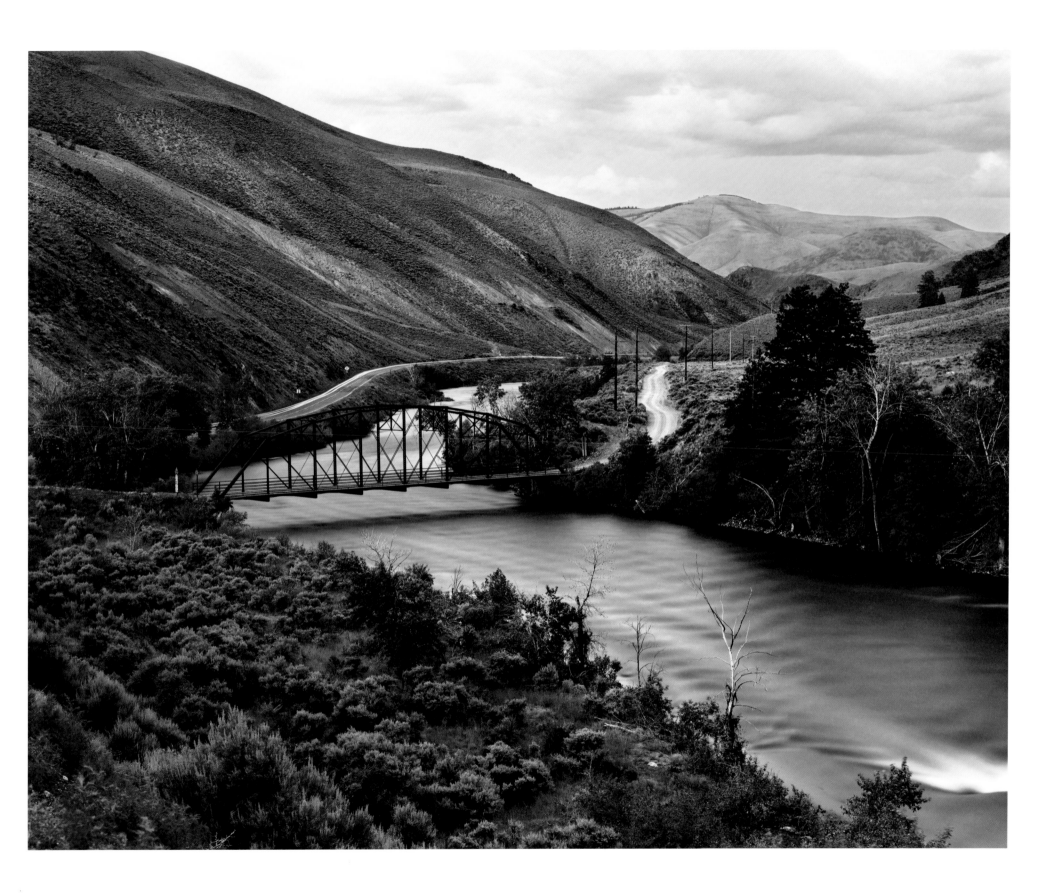

John Willis *Sunka Wakan Na Wakanyeja Awiglipi (To Bring Back the Horse and Child),* Pine Ridge, South Dakota, 2004

This photograph represents the wide-open spaces of the West, in this case the Pine Ridge Reservation. Youths race across the boundless plains, enjoying themselves while giving it their best effort to succeed and holding onto valued traditions. I thought of submitting a portrait of a close friend who inspired the work there, or an image that shows children in joyful play, or another which shows the economic hardship. But none of these would have felt right to me without the others beside it, balancing out the representation of contemporary life for Lakota people. They have such a beautiful culture and traditions.

The political climate surrounding their community continually impacts individuals and the people as a whole. As an outsider who has been welcomed by families for over twenty-six years, I am still keenly aware I am not Lakota. Part of my appreciation for their tribal culture is they have something my family of Jewish heritage gave up when fleeing Europe and persecution in the early twentieth century. I have no relatives left who can speak to our family's past. I grew up in suburbia. I was raised to be grateful for my country and about the melting pot. This lesson I cherished so: that we are all the same, all American, all with equal opportunity. But I have learned that our country is not so fair and just. Maybe nowhere in the world is—I cannot say. I do know indigenous communities and other so-called minorities in the U.S.A. live without the same opportunities as people privileged at birth by race, as I was. Upon my introduction to Lakota people and life on the Pine Ridge Reservation, their distinctive customs and the values they represent compelled me to expand my understanding of what it means to be human. I no longer accept the melting pot notion as reality or even desirable. Nor do I want merely to tolerate cultural diversity, instead I strive to truly benefit from sharing and appreciating it, while also working to do my part in building a more fair and just society.

This chosen image can speak to the injustice of inequality and honors the lives of the Lakota people. The subjects are members of a not-for-profit youth group that teaches traditional values of living at one with nature, and leadership, while providing positive opportunities through skills like horseback riding and archery.

It was both humbling and beautiful to be there.

J.W.

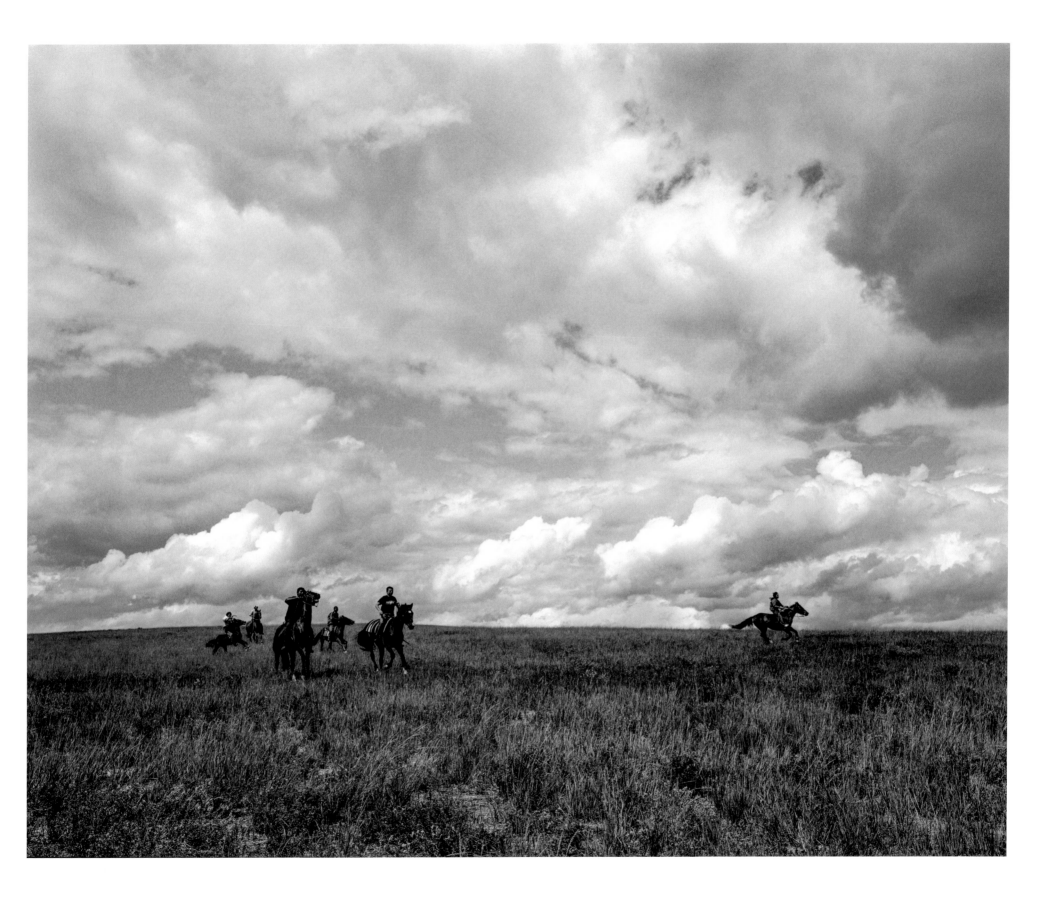

Roberta Price *Reality Construction Company,* Arroyo Hondo, New Mexico, 1969

In the summer of 1969, I was a 23-year-old graduate student in English with a grant to travel west and photograph communes. My partner, David Perkins, and I had read about the communes sprouting up in the West, and we wanted to see what was happening. Don't ask why the English department at SUNY Buffalo gave me a grant from its discretionary faculty fund—it was the late 60s. The department had recently asked Allen Ginsberg to be a professor there (he had refused, because it might look as though he had sold out); a fellow graduate English student's PhD thesis addressed the language of soap operas. My advisor, Leslie Fiedler, supported my project, and I had asked for a mere $700. Gas was 33 cents a gallon. I used some of the grant money to buy a Pentax Spotmatic; the rest was enough to get us through the summer.

In June 1969, David and I rolled up to the locked gate of Reality Construction Company on a high mesa, east of Highway 522 in Arroyo Hondo, New Mexico. Coincidentally, a CBS News team and a *Time* magazine reporter were also at the gate that afternoon. Max Finstein, the *éminence grise* at Reality, walked down the dirt road to meet us. Max had been a poet at Black Mountain College and a founder of New Buffalo, the illustrious commune west of Highway 522 that Peter Fonda and Dennis Hopper recreated for *Easy Rider* scenes after they were denied permission to film the real thing. Max quickly told the reporters from the national news media that they weren't welcome, then looked us up and down and told us we could enter. He eyed the Pentax hanging from my neck and said quietly, "Don't take pictures of anyone's face." I didn't ask why.

So I took a lot of silhouettes and long distance shots. I don't know if I was the only person allowed to photograph the early days at Reality, but I haven't seen many other images from that time. In this photograph, the men are making adobe bricks for the pueblo-style building that was to be Reality's central complex. I was facing west, so the landscape beyond the work crew was almost the same view that D.H. Lawrence had seen from his cabin on Lama Mountain nearby.

The hippies on the rural communes had a well-deserved reputation for Dionysian playfulness, but they worked hard too. That summer the small group at Reality made 17,000 adobe bricks and built the traditional-style, low-slung adobe and log building they would winter in. The crew did not necessarily work efficiently. An alumnus of New Buffalo and Reality later told me that the difference between the two communes was that if the adobe mixture was too wet, New Buffalo men would add more straw, but Reality workers would sit down and wait for it to dry.

I took hundreds of photos that summer as David and I traveled around the communes in the Southwest. Many of the people I photographed had been politically active in cities (which is probably why Max told me to avoid faces), but by then they had begun to think they could create a revolution by living differently in the country. I took more photos when we returned on another grant in the winter of 1970. I started out as a participating observer but became an observing participant—in June 1970, David and I moved to Libre, a community in Southern Colorado, and I continued to photograph for the six and a half years I lived there. The (mostly young) communards whose ranks we joined were part a long tradition of (mostly white) American utopianism that began with the Pilgrims. Sure, some communards were foolish, selfish, and frequently high, but many were also passion-ate, idealistic, even heroic. Unlike young people today, our generation was riding on a tidal wave, and we had the recipe for change. The western landscape was the backdrop for the grandeur of our dreams, as it had been for other dreamers before us. Almost fifty years later, looking at these photographs, I love the geography just as I did then. But now as I examine the figures, I see more clearly the beauty and exuberance of youth.

R.P.

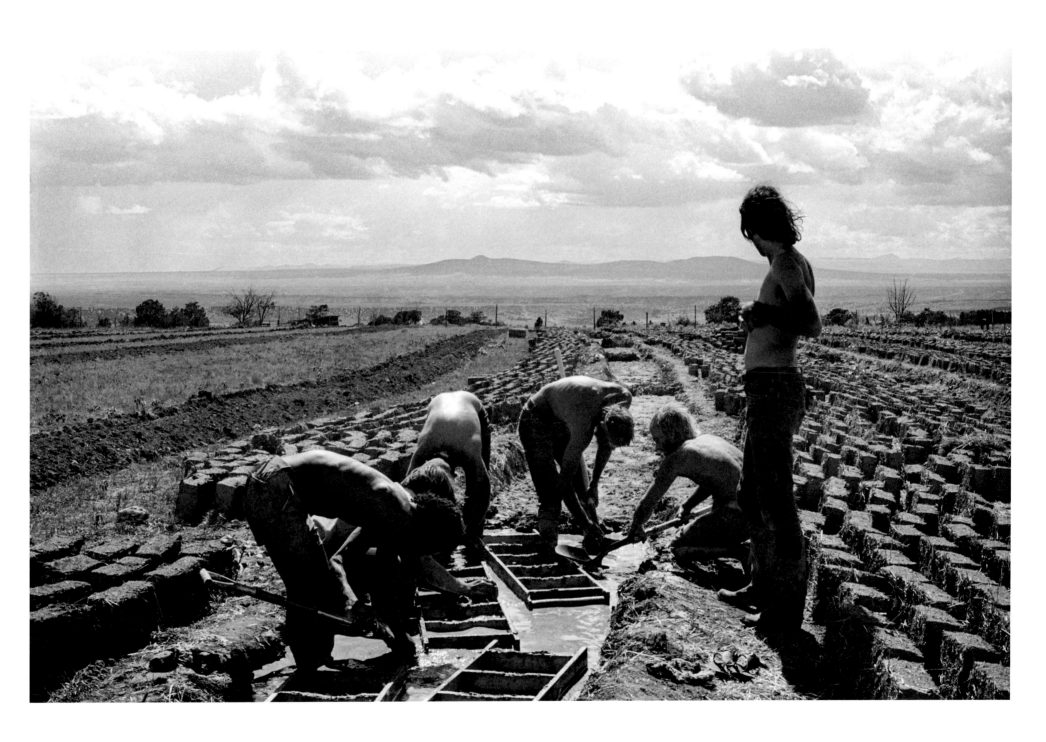

David Grant Noble *Wild Rice Harvesters Returning,* Nett Lake, Minnesota, 1971

For most Americans the enduring image of Native Americans involves a horse (Lakota), a desert (Hopi) or both (Apache). Fifty years ago, when David Noble learned that Manhattan skyscrapers were being built by Mohawk steelworkers, he began a photographic project that reveals the incredibly varied patterns of life and work found among the indigenous communities of North America.

The legends of the Bois Forte Band of Chippewa (also called Ojibwe or Anishinaabeg) describe a great vision that led the people westward through the Great Lakes searching for *manomin,* "the food that grows upon the water." In northeastern Minnesota they encountered Nett Lake which encompasses 7,400 acres and holds the largest contiguous wild rice beds in the world. Today, the lake produces approximately four million pounds of wild rice each year.

The Bois Forte Chippewa have never used fertilizers, pesticides, or outboard motorboats on Lake Nett. Each September they harvest the rice (which is actually a legume) by hand. One person poles a canoe through the wild rice beds while another uses hefty sticks to bend the grassy plant over the canoe and knock the rice into the boat. In rhythmic fashion a canoe can be filled with as much as 200 pounds of wild rice in a few hours.

At first glance, Noble's image of a Chippewa couple returning to shore after harvesting wild rice might seem a nostalgic tribute to the survival of customary ways against the imposition of modern industry, but a closer reading reveals signs of much greater complexity. The couple's adoption of modern clothing and headwear, apparent in Noble's photograph, suggests that traditional approaches to sustaining and harvesting wild rice among the Bois Forte co-exist with cultural and economic innovation. Indeed, while the Chippewa continue to rely upon Lake Nett's wild rice to feed them, they have also developed commercial businesses, individually and as a tribal venture, which employ the Internet to market and sell surplus rice throughout the United States.

Like the Bois Forte Band of Chippewa, indigenous communities throughout the United States draw upon their history and culture to develop creative responses to the evolving demands of contemporary life. Tradition is a guide, a resource, neither a refuge nor a sentence. As placid as Noble's photograph may initially appear, it is also about the unseen ripples beneath and beyond the canoe at its center. It presents us an opportunity to step beyond the bounds of conventional iconography of Native American culture to contemplate the dynamic circumstances of modern Indian life.

G.M.

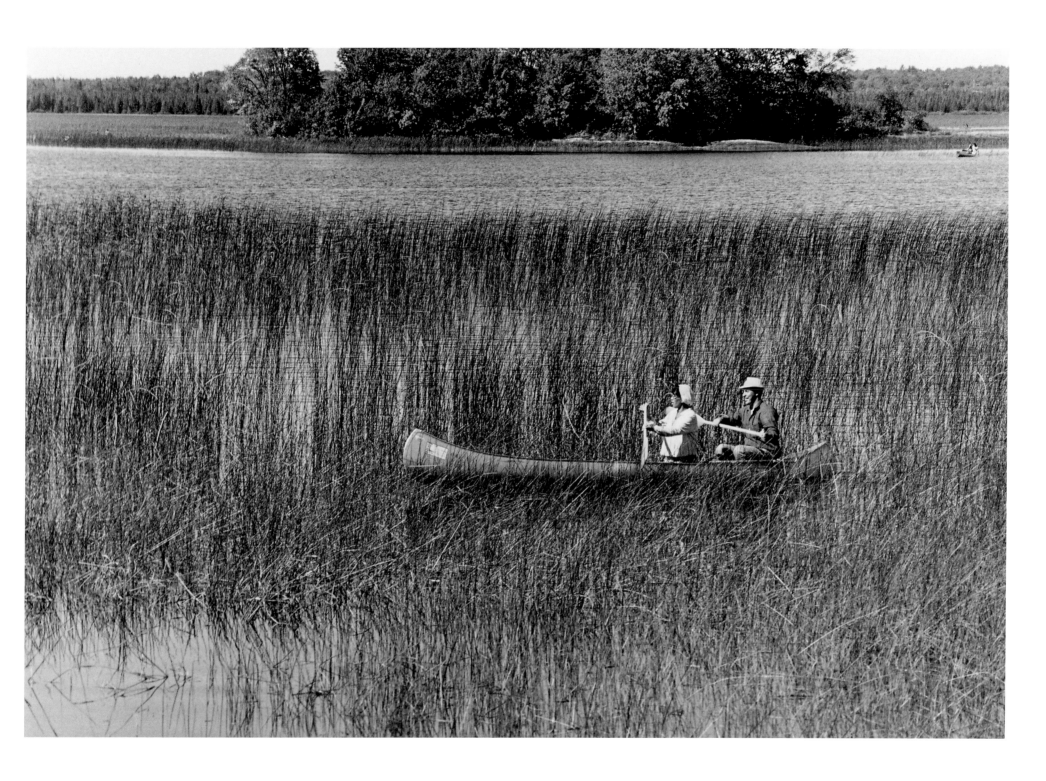

Miguel Gandert *Voces de la Tierra: Planting Winter Wheat,* San Luis, Colorado, 1997

The Nuevo Mexicanos or Hispanos of the southwestern United States trace their ancestry not only to the Iberian Peninsula but also to the indigenous villages of Mexico. Their ancestors first migrated to the Rio Grande Valley in the late sixteenth century. Frequently cut off from the cultural centers of New Spain, they developed a unique mestizo culture that integrated European and Native American traditions. In 1848, at the end of the Mexican War, the Treaty of Guadalupe Hidalgo made them American citizens, but, despite the many ways in which the Southwest has changed over the last 150 years, the people have retained a distinctive cultural identity.

Born in Española, New Mexico in 1956, Miguel Gandert began making photographs in high school. An ethnographer with a camera, he has worked with historians, sociologists, folklorists, and the community to create a visual record that explores the religious, social, and economic patterns of New Mexico through the faces and lives of individual Nuevo Mexicanos. His photograph of a father and son planting winter wheat is part of a series, "Voices of the Earth," that explores the heritage of subsistence farming in the San Luis Valley of southern Colorado.

On April 5, 1851, near the headwaters of the Rio Grande, Hispano settlers established the village of San Luis de la Culebra on land granted to New Mexican merchant Charles Beaubien in 1844. To entice settlers, Beaubien offered small property grants to individuals and set aside more extensive common lands on which residents could graze stock, hunt, fish, and gather wood.

Once the northernmost settlement in New Mexico, San Luis became part of Colorado when the territory was formed in 1861; the village is recognized as the oldest continuously inhabited settlement in the state. Many, perhaps most, of its contemporary residents have family ties to original settlers.

In 1863 Beaubien sold his rights to William Gilpin, the first Governor of Colorado Territory. The settlers and Gilpin soon clashed about their rights to land and resources. Suits and countersuits have been filed ever since, particularly when a new investor, usually from out of state, attempts to restrain residents from using what has long been regarded as community property. In 1997 controversy flared when a Houston oil executive, Lou Pai, installed an extensive system of fences to restrict access to lands to which he claimed title.

Amidst the legal and political contests over residents' rights, Gandert's black and white images explore the evolving traditions of a rural community. Almost certainly prone when he captured this image, Gandert makes the soil and its produce central elements of his composition. We look over and through wheat stalks, past a rocky bed of dirt that borders the field where a man and young boy, presumably father and son, ride a tractor and seed drill. Their machinery is modern but modest. Dust thrown up by the tractor obscures the figures but also reminds us of the intimacy of their relationship to the soil. At a time when agribusiness has reshaped much of the West, this is a family farm in which multiple generations are invested.

G.M.

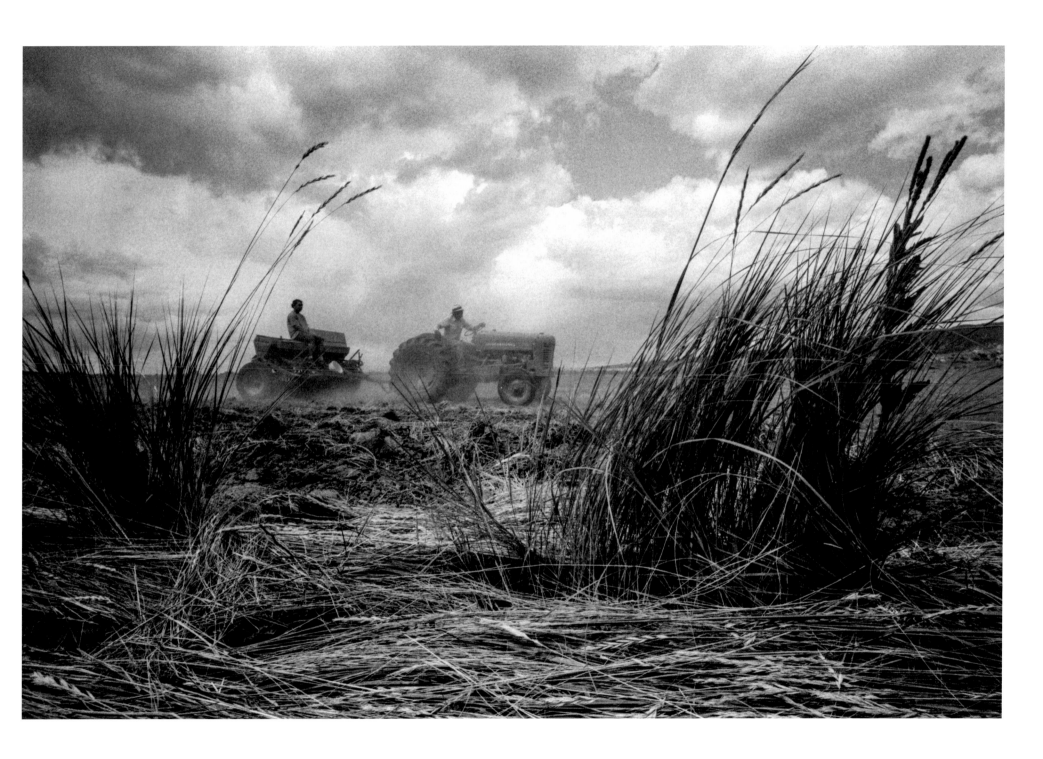

Jon Lewis Untitled photograph of a boy and young man harvesting grapes, Arvin, California, 1966

Photographers want to show us something. Some encourage us to contemplate the color of light or the nature of vision, projects analogous to the way lyrical poets explore the sound and rhythm of language. Others, like writers of long-form non-fiction, may challenge us to look closely at disquieting aspects of our society, to consider things that we rarely encounter in person. This modest photograph, made by Jon Lewis, of the grape harvest at El Rancho Farms in Arvin, California, in 1966 represents what is often called documentary photography.

Many photographers resist being described as documentary photographers because the term may suggest that they are merely recording what is before them rather than creating original art. The democratization of picture-making made possible by the inclusion of digital cameras in cell phones compounds the professional crisis. Social media overwhelm us with images of the world "out there." What distinguishes documentary photography as art, as profession, from photography as mundane cultural practice?

The proliferation of digital media and the disruption of print culture have created economic challenges for people seeking to make a living as a photographer. The same qualities that distinguished Jacob Riis and Lewis Hine from the capable but uninspired operators of local portrait studios at the beginning of the twentieth century distinguish contemporary photographers who are creating bodies of socially and culturally significant images from the many eager, technically competent, but undisciplined amateurs who post on social media. Craftsmanship is necessary but insufficient to depict the world in ways that challenge our perception of it, that stir us to change it. Engagement, persistence, a commitment to looking closely, over time, at something others cannot or do not want to see is essential. So too is the ability to recognize when events present an opportunity to capture an image that embodies the subject.

Jon Lewis traveled to Delano, California in January 1966, a few weeks before he was scheduled to start graduate school at San Francisco State College. He intended to make a few photographs of the nascent efforts of the Agricultural Workers Organizing Committee (AWOC), led by Larry Itliong, and the National Farm Workers Association (NFWA), led by Cesar Chavez and Dolores Huerta, to organize California's migrant farm workers. He stayed for eight months and returned in the summer and fall of 1967. Exposing more than three hundred rolls of 35mm film, he created a unique visual record of the origins of the United Farm Workers.

Lewis enjoyed direct access to union staff and their supporters, but depicting work in the fields of California's central valley was more difficult. Vineyard owners had no interest in assisting him. Occasionally, when work occurred near public avenues, Lewis could capture images like this photograph of a boy kneeling next to a young man, perhaps his father, in the fields of El Rancho Farms. Lewis has framed them between boxes of harvested grapes, juxtaposing the abundance of the field with the hard, manual work that helped create commercial value. In doing so, he prods us to consider whether that value is justly distributed.

G.M.

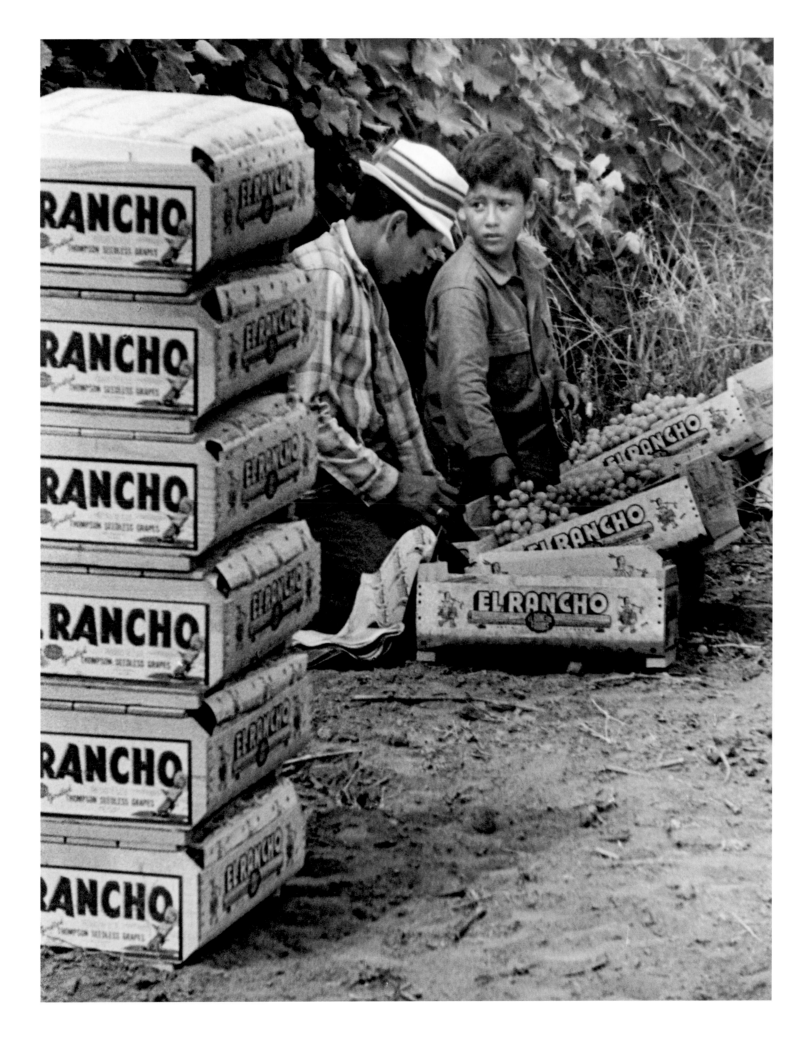

Jon Lewis *Cesar on the March to Sacramento,* between Delano and Sacramento, California, 1966

Sometimes to fully appreciate the power and significance of a photograph we must forget what we "know" about its subject. When Jon Lewis made this portrait of Cesar Chavez in the spring of 1966, Chavez was not an American historical icon. He was not a renowned hero of the movement for Latinx civil rights in the United States, not a recipient of the Presidential Medal of Freedom. He was a 39-year-old labor organizer who had spent 15 years working among Mexican-American communities throughout California with minimal success.

Chavez left school after seventh grade in 1942 to work in the fields so that his mother could remain at home. In 1952 he joined the non-profit Community Service Organization founded by Fred Ross, Antonio Rios, and Edward Roybal and sponsored by Saul Alinsky's Industrial Areas Foundation to mobilize Mexican-American social and civic energies. In 1962, frustrated by Alinsky's refusal to support their efforts to organize California's migrant farm workers, Chavez and Dolores Huerta left CSO to found the National Farm Workers Association. Three years later, the NFWA comprised twelve hundred members, of whom only about two hundred paid dues.

In retrospect it is easy to claim that Chavez and Huerta were destined to change the arc of Mexican-American history, that Chavez's famous motto *Si, se puede* (Yes, you can) was not merely an aspiration, but a prophecy, that the 340-mile march from Delano to Sacramento that the NFWA organized in support of migrant farm workers was certain to transform the history of agricultural labor in California.

On March 17, 1965, when he took the first steps of that march, little or none of that was clear. Lewis's portrait captures a pensive Chavez, crouching beside a banner that summarized the purpose of the march, *Peregrinación, Penitencia, Revolución* (Pilgrimage, Penance, Revolution). Prepared to endanger his health in an effort to draw national attention to the union campaign, about to embark on a campaign he knew could shape the lives of millions of Mexican-Americans for better or worse, Chavez evokes Caesar before Gaul, Eisenhower before Normandy, King before Selma. He is a leader responsible not only for himself but the many people he has persuaded to follow him. As we look at him staring into the future we gain a glimpse of the courage and sense of purpose that led him to step into an undetermined future, to become Cesar Chavez, the historic figure we "know."

G.M.

Owen Luck *Wounded Knee, 1890 • 1973 February "Cannapopa Wi"—The Moon of Popping Trees,* Pine Ridge, South Dakota, 1973

As a new moon arrived, the Lakota people noticed a great change. Trees on the Great Plains popped and burst as their branches became laden with winter snow and ice.

<div align="right">Akta Lakota Museum & Cultural Center</div>

I do not recall the names of all four men in this image, but Chief Tom Bad Cobb is the one holding the cane. As I recall Tom was in his 80s when he confided to me that he grew up with stories of the old days, but later he had become a roadside "Indian Chief," drunk and posing in his regalia for change from tourists along the desolate roads of the Pine Ridge Reservation in South Dakota. Tom told me how AIM (American Indian Movement) had awakened him. He said that he was at Wounded Knee to support the young Native American men and women who had gathered to demand that their treaty rights be honored, and said that the Lakota needed to stop the corrupt regime of Tribal Chairman Dick Wilson and his GOONs (Guardians of the Oglala Nation), who were armed by the FBI, the U.S. Marshals, and the Bureau of Indian Affairs, from discriminating against traditional Lakota Oyate. He asked if I had seen the postcards of the mass grave, or of Chief Big Foot frozen in the snow. I told him I had. He spoke in his tired voice, "You know Sitting Bull was killed in December that year when they attempted to arrest him on the Standing Rock Reservation. I guess Big Foot was next on their list."

As I review this photograph of four Lakota elders seated outside Gildersleeves Trading Post, 83 years, 1 month and 27 days after the 1890 Massacre of nearly 300 Miniconjou Lakota men, women, and children, I remember wondering if I was to witness a similar "great reckoning." Wounded Knee Creek was once again surrounded by armed elements of the U.S. government. Was this to be an historic atonement, a reconciliation, or yet another slaughter?

Today I am still beset with recollections of the dread I felt during those gravely disheartening days as I realized that Lakota cries for parity would not be recognized. By the end of the Liberation of Wounded Knee, Frank Clearwater, a Cherokee man, had been killed by the FBI or U.S. Marshals when they fired armor-piercing 7.62mm M60 machine-gun rounds into the basement of a church during an air lift that dropped two tons of food for those trapped in the liberated area who were suffering from the government's "Starve them out" strategy.

Buddy Lamont a full blood Lakota and Vietnam Veteran was assassinated when a U.S. government sniper shot him as he walked unarmed through the hamlet of Wounded Knee in broad daylight. One FBI agent was shot and paralyzed. Many AIM supporters were wounded and dozens would go missing, never to be heard from again. On a positive note amidst the list of tragedies, Mary Crow Dog gave birth to her and Leonard Crow Dog's son Pedro.

In the year following the Liberation of Wounded Knee, sixty American Indian Movement supporters would be murdered, including Pedro Bissonette, director of the Oglala Sioux Civil Rights Organization (OSCRO). Residents of Pine Ridge complained of retaliation by Dick Wilson's GOONs. Between March 1, 1973 and March 1, 1976 170 people were murdered at Pine Ridge.

The last time I saw Chief Tom Bad Cobb we were gathered at the Rapid City Jail as the AIM warriors were being brought in, shackled and handcuffed, surrounded by heavily armed officers of the FBI and U.S. Marshals. Tom stood alone with his cane raised over his head. He danced and sang a Lakota lament for hours until the last warrior was imprisoned. Then he got into his old pickup truck and drove away. I treasure the photograph I made of him that day, cane raised high in pride and defiance.

<div align="right">O.L.</div>

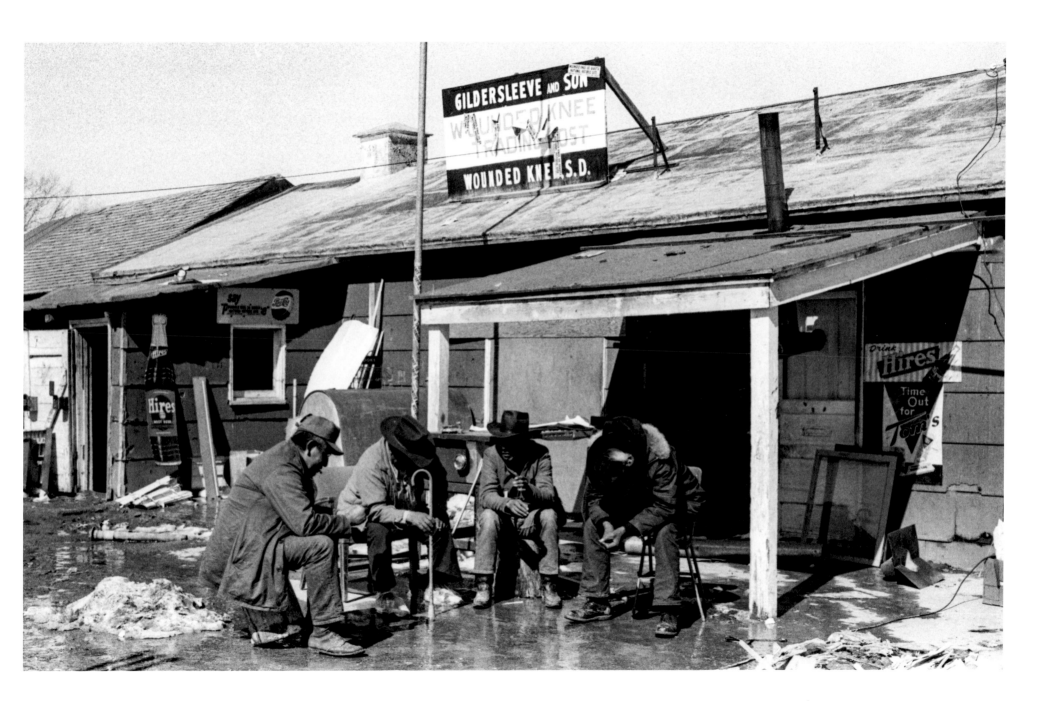

Toba Pato Tucker *Ruby Gishal and Betty Bedoni,* Jeddito, Arizona, 1981

When I picked up a camera at the age of forty-two in 1977 I discovered the road to my life's work. This led me to the world of Native Americans in the Northeast and Southwest and for several decades I recorded the continuity and changes in their communities, making documentary portraits of individuals, couples, and generational photographs.

In recent years I have turned my eye to documenting the awe-inspiring landscapes of the West and Southwest contrasting my new images with the vintage nineteenth-century landscapes in the Yale Collection of Western Americana at Beinecke Library, sometimes pushing the classic boundaries of the American West to Alaska and Hawaii.

The first Native person I photographed was a young Chippewa Indian in St. Paul, Minnesota, when I was photographing people on the street. As the image emerged in the developer, I was fascinated by the mysterious persona before me and promised myself that, if I ever had the funding, I would photograph Native people.

In 1980, a National Endowment for the Arts Fellowship enabled me to begin my journey into the world of Native American culture. To this day, I cannot answer the question I am often asked: why did I immerse myself in a culture so different from my own and for so many years? Perhaps it is because Native Americans have had to overcome many generations of adversity that they present themselves to my camera with an inner pride on their serious faces, revealing a wordless dignity that invites respect by the viewer. I find this compelling.

I made the portrait of Ruby Gishal with her mother, Betty Bedoni—Navajo Indians from Jeddito, Arizona—in 1981 while working with the Navajo–Hopi Land Dispute Commission in 1981. My introduction to these women came about through my association with Percy Deal, who at that time was director of the commission. Meeting Percy Deal was one of the more memorable experiences of my photographic career. He took me to a Chapter House, a traditional meeting place, for the people to view my photographs. Percy wanted me to make portraits of his people to show the world their faces to promote better understanding of the U.S. government's effort to remove Navajos from land on the Hopi Reservation—and I promised to do that.

The Chapter House was a small cinderblock building containing just a large old desk and two chairs. It was dry hot. Leaning against the wall were six silent Navajo men, all dressed in jeans, boots, cowboy hats, and traditional turquoise, convened for the purpose of meeting me and seeing my photographs—very intimidating to a tenderfoot New Yorker.

In viewing my portfolio, Percy said the black paper used as a background for my portraits looked "commercial" and would be alien to his people and therefore unacceptable. I told him that for the Navajo portraits I planned to use a black wool Pendleton blanket I purchased at the local trading post.

I went to the old Chevy van I was driving and living in, and brought in the blanket. Percy felt the blanket very carefully with his fingers, smiled, and said yes, this is meaningful to my people. We raise the sheep to weave wool. Then he said, come have a hamburger with us—his way of accepting me and giving me permission to photograph the Navajo people. And this began my journey photographing Native Americans.

T.P.T.

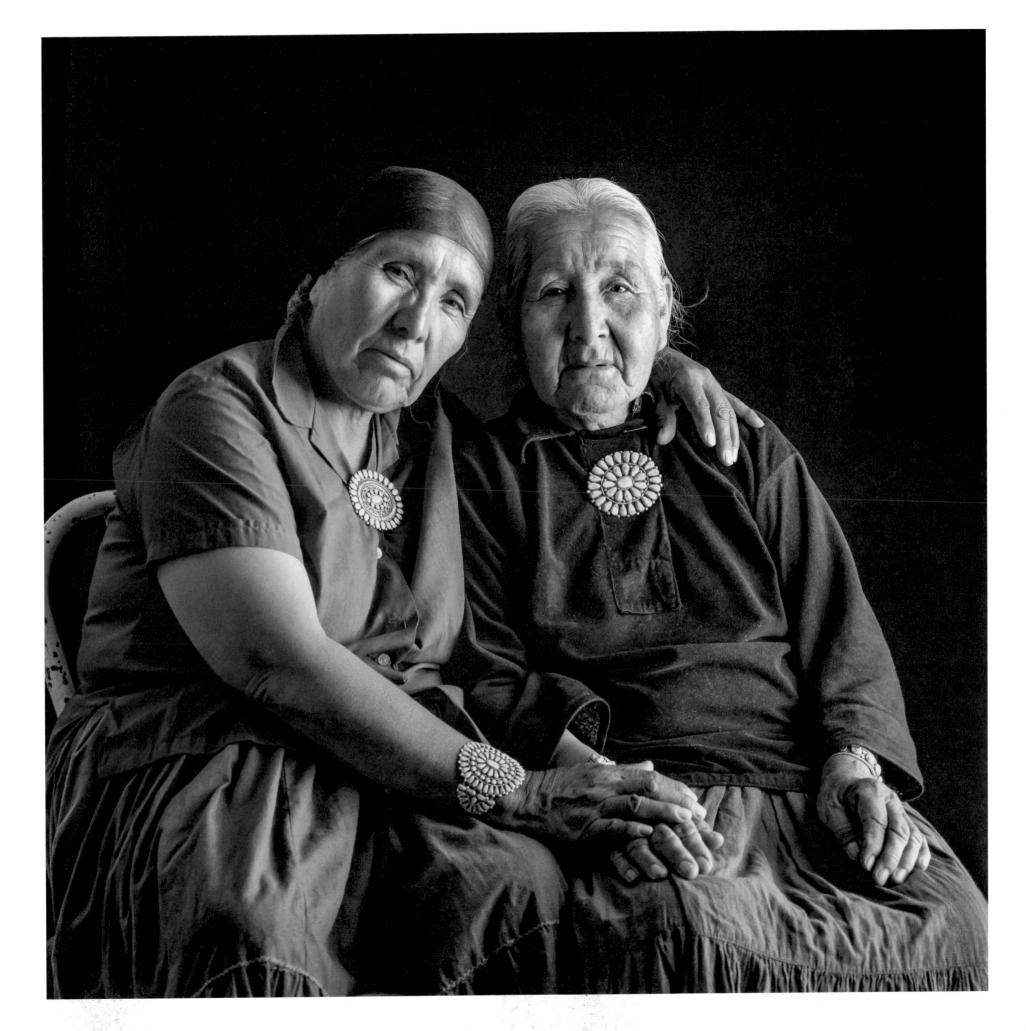

Abe Aronow *Golden Face, Halloween, The Castro,* San Francisco, California, undated

Portrait photography frequently occurs under tightly controlled circumstances. The photographer determines the backdrop, the lighting, perhaps even the attire and pose of the subject. If studio portraiture is about staging the scene, street photography challenges the artist to respond fluidly to opportunities presented by the flow of daily life. But great street photography is neither random nor unplanned. Like *flâneurs,* successful street photographers develop an intimate relation with their community. They know its rhythms, its gathering places, its inhabitants. Some great practitioners have worked surreptitiously, capturing images while barely drawing the attention of their subjects; others engage their subjects in magically brief moments of intimate contact.

For nearly thirty years, beginning in 1981, Abe Aronow carried a camera as he walked the neighborhoods of his adopted hometown, San Francisco. Traveling between Laguna Honda and Market Street, from Haight-Ashbury to the Mission District, from downtown to the Castro, he came to know the times and places where people would reveal their personalities as well as the character of daily life in the Far West's first, and most-enduring, metropolis.

Among Aronow's favorite places to visit was the Castro, a neighborhood that Scandinavians had developed at the beginning of the twentieth century. By the 1930s an influx of Irish and Italian immigrants had created a vigorous, ethnically mixed, working-class area. By the late 1960s the descendants of those families were moving to suburbs in the East Bay, and the Castro

became an attractive location for San Francisco's LGBTQ community to settle. Politically astute, socially minded, and culturally innovative, the residents of the Castro created a vibrant neighborhood that came to be recognized as a major center of gay life in the United States.

Even as they formed new social relationships, the gay residents of the Castro incorporated existing traditions including a community-wide celebration of Halloween that had begun in the 1940s. In 1989, a few weeks after the Loma Prieta earthquake, a local queer community service organization, the Sisters of Perpetual Indulgence, performed street theater to solicit thousands of dollars in contributions to the mayor's Earthquake Relief Fund from the crowds that poured into the Castro to participate in the city's most famous Halloween party. By 2002 the celebration had grown to include nearly 500,000 people.

We do not know the year in which Aronow visited the Castro on Halloween, but that day he persuaded a young woman to pause, to look his way, to collaborate, deliberately, with him in recording the spirit of the day. Had she decorated her face to perform, or was she simply expressing her solidarity with the community? The photo doesn't answer, but her engagement with Aronow, her willingness to interrupt her day, to offer a modest, perhaps sheepish smile, suggests to us that whatever she is about to do will connect her with her community. Hers is a singular but not a solitary portrait which offers us the opportunity to imagine our own connections across time and space.

G.M.

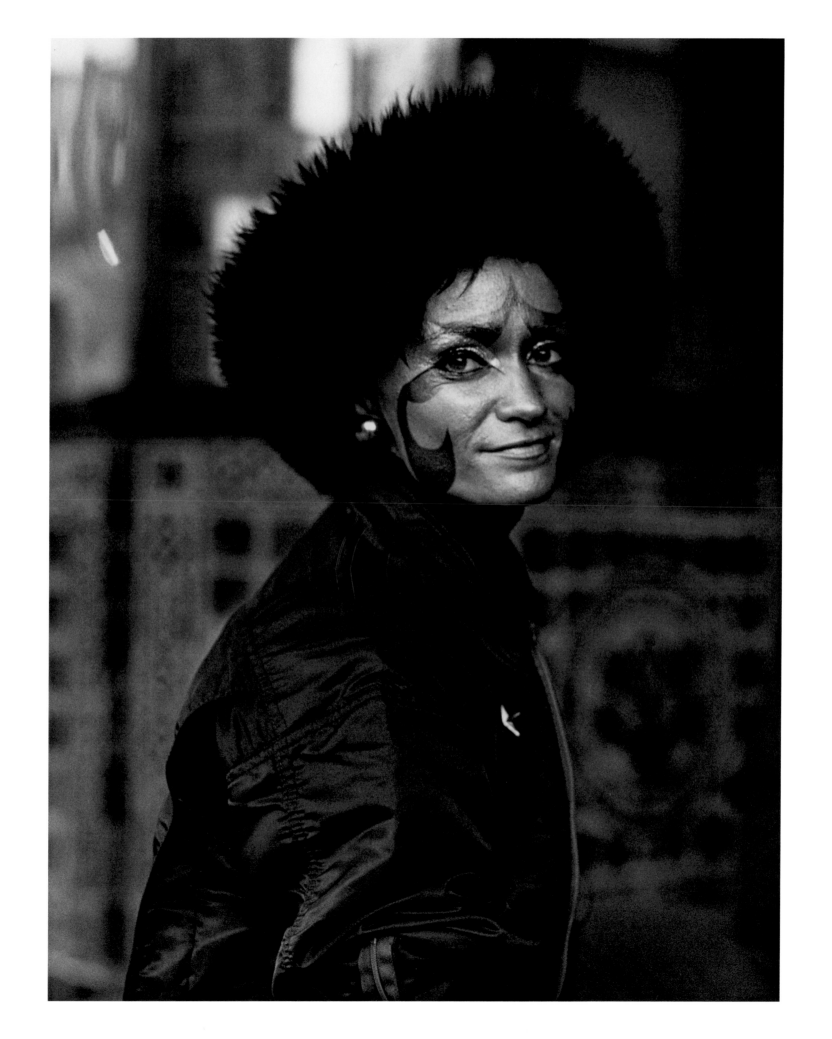

Will Wilson *Insurgent Hopi Maiden, Talking Tintype,* 2015

As an indigenous artist working in the twenty-first century, employing media that range from historical photographic processes to the randomization and projection of complex visual systems within virtual environments, I am impatient with the way that American culture remains enamored of one particular moment in the photographic exchange between Euro-American and Aboriginal American societies: the decades from 1907 to 1930 when photographer Edward S. Curtis produced his magisterial opus *The North American Indian.* For many people even today, Native people remain frozen in time in Curtis's photos. In 2001, six Native artists collaborated with Jill Sweet and Ian Berry of Skidmore College in an exhibition, *Staging the Indian: The Politics of Representation,* which employed humor and other approaches to melt the lacquered romanticism of Curtis's stereotypical portraits.

I seek to do something different. I intend to resume the documentary mission of Curtis from the standpoint of an indigenous, trans-customary, cultural practitioner. I want to supplant Curtis's Settler gaze, and the remarkable body of ethnographic material he compiled, with a contemporary vision of Native North America.

I propose to create a body of photographic inquiry that will stimulate a critical dialogue and reflection around the historical and contemporary "photographic exchange" as it pertains to Native Americans. My aim is to convene with and invite indigenous artists, arts professionals, and tribal governance to engage in the performative ritual that is the studio portrait. This experience will be intensified and refined by the use of large format (8 x 10) wet-plate collodion studio photography. This beautifully alchemic photographic process dramatically contributed to our collective understanding of Native American people and, in so doing, our American identity.

In August 2012, at the New Mexico Museum of Art in Santa Fe, I initiated the Critical Indigenous Photographic Exchange (CIPX). This was the initial spark for an ongoing intervention into the history of photography. I aim to link history, form, and a critical dialogue about Native American representation by conversing with participants while making their portraits using the wet-plate process. This multi-faceted engagement will yield a series of "tintypes" (aluminum types) whose enigmatic, time-traveling aspect demonstrates how an understanding of our world can be acquired through fabricated methods. Through collaboration with my sitters I want to indigenize the photographic exchange.

I will encourage my collaborators to bring items of significance to their portrait sessions to help illustrate our dialogue. As a gesture of reciprocity, I will give the sitter the tintype photograph produced during our exchange, with the caveat that I am granted the right to create and use a high-resolution scan of his or her image for my artistic purposes.

Insurgent Hopi Maiden, one of the CIPX series, references George Lucas's appropriation of the Hopi Maiden hairstyle for the Star Wars character, Princess Leia. By downloading the free LAYAR app on a smart device, viewers can scan the image and access a counter appropriation in which the portrait's subject, Melissa Pochoema, rewrites Princess Leia's secret message to Obi-wan Kenobi.

Ultimately, the objective of the project is to ensure that the subjects of my photographs are participating in what postcolonial critic Homi K. Bhabha has termed the "re-inscription of their customs and values in a way that will lead to a more equal distribution of power and influence in the cultural conversation" (see his chapter, "Caliban Speaks to Prospero . . . ," in *Critical Fictions: The Politics of Imaginative Writing,* 1991). It is my hope that these Native American photographs will represent an intervention within the contentious and competing visual languages that form today's photographic canon. This critical indigenous photographic exchange will generate new forms of authority and autonomy. These alone—rather than the old paradigm of assimilation—can form the basis for a re-imagined vision of who we are as Native people.

W.W.

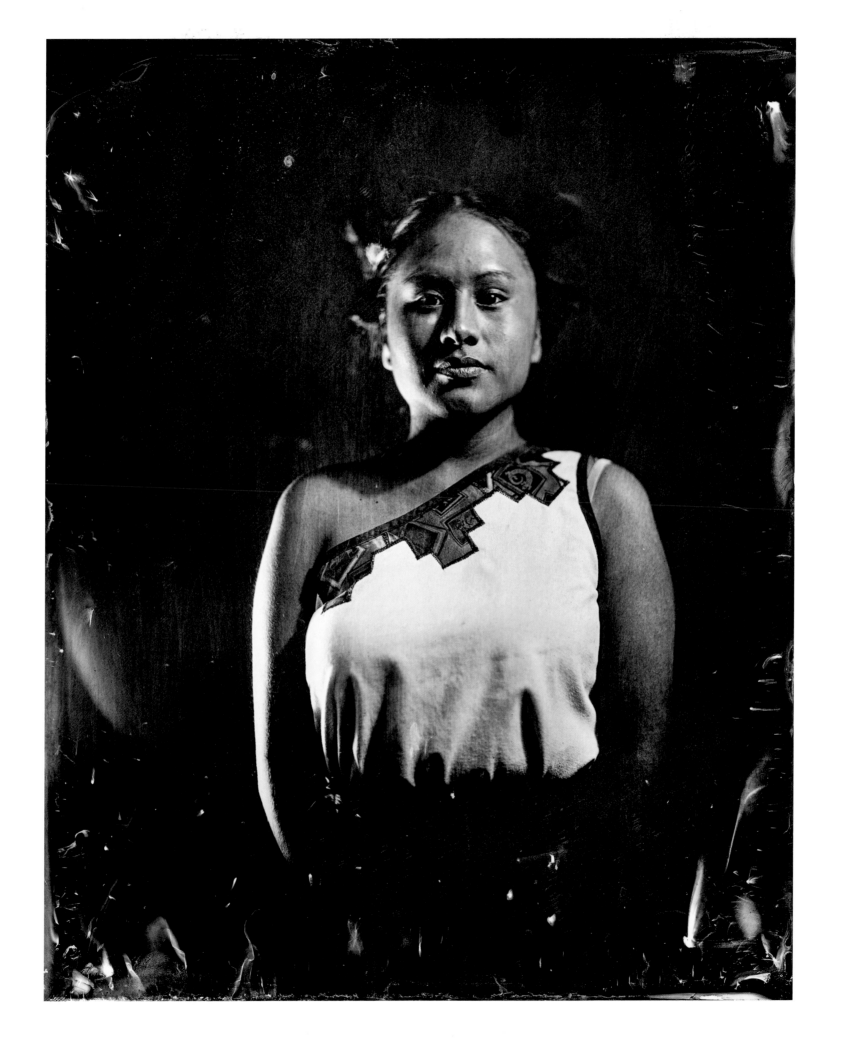

Roberta Price *New Mexico State Fair Portrait Project, Father and Son,* Albuquerque, New Mexico, 2010

Photography revolutionized portraiture. Sitting for a daguerre-otype was dramatically less expensive than hiring an artist. No longer was a portrait something that only the rich could afford. In 1849, 100,000 daguerreotype portraits were taken in Paris alone. Ten years later, the widespread adoption of the carte-de-visite simplified the production of multiple prints from a single sitting and further reduced portrait costs. When the original Kodak box camera was released in 1888 it ushered in an era of family photo albums filled with snapshots of relatives. It should not surprise us that our social media feeds are awash with cellphone "selfies." We love to see what we, our families, and our friends look like.

In 2009, John Boyd, an Albuquerque attorney, conceived a project built upon our fascination with personal portraits. Boyd knew that the New Mexico State Fair, an annual festival featuring concerts, competitions, rodeos, rides, games, animals, agricul-ture, and art, routinely drew nearly a half a million people from across the state's many ethnic and cultural communities. Recog-nizing an opportunity to document New Mexico's extraordinary diversity, he gathered a group of local photographers who joined with him to found the New Mexico State Fair Portrait Project.

The project photographers created a makeshift studio but also walked through the fair, looking for opportunities to capture people at work and play. As Boyd explained,

If you walk up to folks on the street and try to take pictures of them, they'll usually tell you to get lost. But, if you walk up to people at the State Fair—where everyone is in a good mood and dressed expressively—and you happen to be wearing a conspicuous sort of State Fair ID-tag, they're happy to let you snap away! They'll go to a studio, stand in front of a convenient wall, or take their shirts off to display their tattoos.

For Roberta Price, one of the founding photographers, the project has been about exploring the many ways in which people simultaneously express both their cultural and personal identi-ties. She remembers being intrigued by the way this young father embellished his traditional garb with the team logo of his favorite professional football team, acknowledging the fact that being fashionable has always been about adding a distinctive personal touch to traditional or prevailing styles of dress.

Since 2009, the photographers have shared their work in multiple venues including the fair itself. In 2014, Mary Anne Redding reviewed the thousands of portraits made during the first five years of the project and curated an exhibition that was shown not only at the Santa Fe University of Art and Design's Marion Center for Photography, but also at Counter Culture Café, a popular Santa Fe restaurant.

G.M.

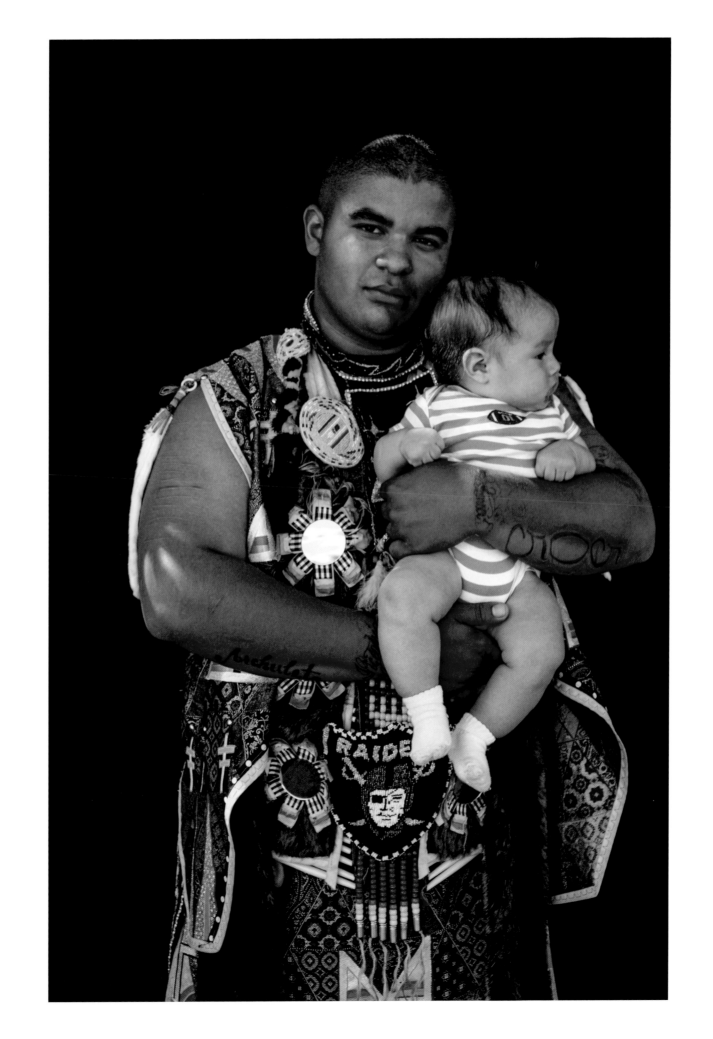

Karen Halverson *Untitled, New Orleans (5860),* Louisiana, 2014

One of the most discussed comments about twentieth-century American photography is Gary Winogrand's observation, "I photograph to see what the world looks like in photographs." For Winogrand, photographs were interesting not as representations of something else, but as autonomous objects whose significance and meaning lay in themselves rather than in what was happening at the moment he captured the image. A blunt, enigmatic declaration of artistic independence, it has inspired and provoked much insightful commentary about the nature of photography.

The anonymous young man in Karen Halverson's portrait, taken along the Mississippi River levee in New Orleans, inverts Winogrand's perspective. His assertive pose and clear engagement with Halverson say, "Photograph me to see me, to remember me, to share me." If Winogrand insists upon the photographer's freedom to make an image with little or no correlation to its subjects, Halverson's collaborator asserts that this photograph will be about him, that through it he will reveal himself, declare his identity, and shape our perception of him. He doesn't so much contradict Winogrand as remind us of the myriad ways that photographic subjects, especially animate ones, influence the making and meaning of photographs.

The portrait is part of a series which Halverson created during an extended visit to New Orleans. During her travels along the levees, she encountered many people who shared her subject's interest in posing, in collaborating with her to reveal and memorialize themselves:

> I marvel at the human promenade before me. New Orleans is made for display. People stroll and strut on the levees, inviting a response. I feel like a casting director with too many choices. I give a nod and a stranger in bold color says yes. We all know the city is famous for its extravagant parades. But, for me, the serendipitous encounter on the levee is more thrilling than working the Mardi Gras parade.

The assertion of personal identity in public space has an extraordinary tradition in New Orleans. In colonial times, slaves were given Sundays off and allowed to gather in open spaces where they played music and socialized. In the centuries since 1727, when the first, 18-foot-wide levee was completed, people of all ages and backgrounds have traveled along them to take in views of the Mississippi, to mingle, and to be seen. And, it seems, to have their picture taken. Like great film stars and fashion models, they court—might we say seduce?—the photographer into seeing them. With Halverson's sensitive collaboration, they project their self-shaped image across time and space.

G.M.

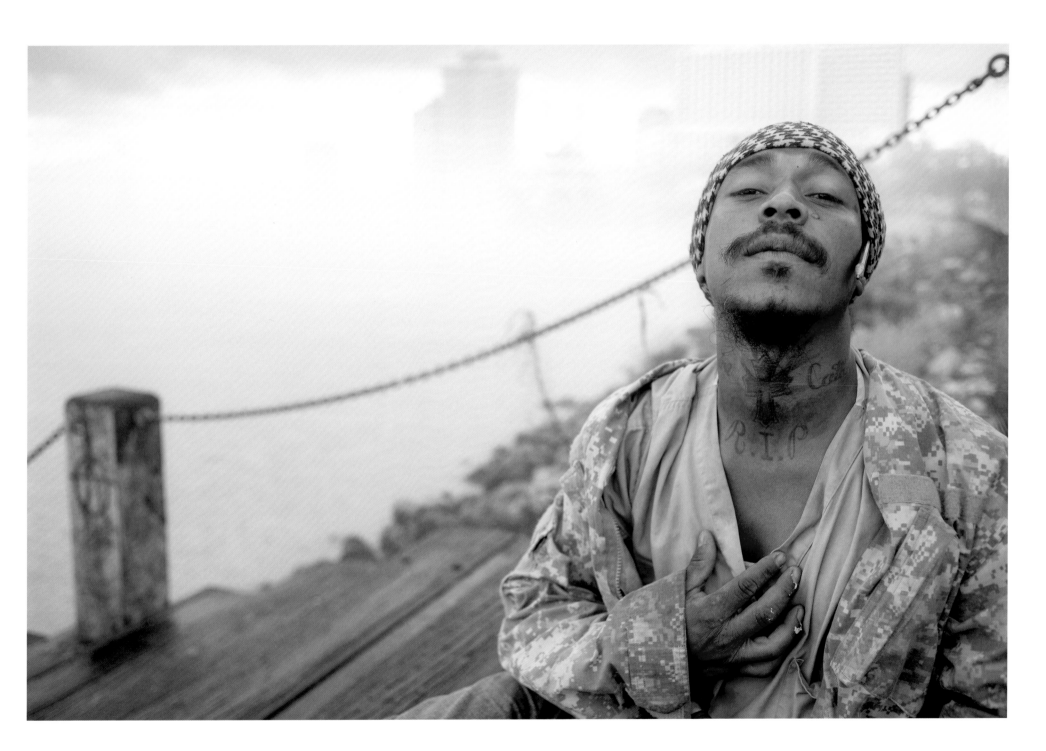

Laura McPhee *Wing of a Great Horned Owl Killed by a Golden Eagle, a Burl, a Log Cabin, and Isobel,* Jerry Peak Wilderness, Idaho, 2015

Laura McPhee's portrait of her daughter, Isobel, was made with an 8 x 10 view camera, an instrument whose fundamental design dates from the 1840s. Contemporary view cameras incorporate modern materials, but they are bulky, complex instruments which require photographers to compose and manually focus an inverted image of their picture on a ground glass at the back of the camera. Only then is a film negative placed in the camera to be exposed. View cameras allow photographers great control over composing their images, as well as extraordinary detail in the large format film they accommodate, but they represent the antithesis of "snapshot" photography. When used to make a portrait, they require great patience from the sitter. Here McPhee asks Isobel to collaborate in making a portrait that carries multiple levels of meaning, some of which are broadly accessible to any viewer, while others are tied to family history.

Leaning forward, arms tucked in tight, with her hands cradling her head, Isobel sits pensively on the stoop of a weathered log cabin, framed by the wing of a great horned owl and a gnarled burl. The wing appears as if it might grow from Isobel's back, part of an angelic being rather than the remnant of a deceased raptor. The varied colors and textures of the burl and cabin contrast with Isobel's simple attire and smooth, youthful skin: Innocence and Experience set side by side.

McPhee has said that she considers it her lifework to "look at and understand the language of a place." In a portrait that foregrounds life and death, perhaps it is the log cabin in the background that speaks most eloquently for this place. The cabin consists of downed trees but also the human labor that felled them and built a home. The logs are dead, but they sheltered a family of seven. The cabin's presence reminds us of our complex relationship with nature, of the ways we transform the world about us to sustain not only our individual lives but those of our children.

The cabin might speak especially loud to McPhee. Isobel's great-great-grandmother, Glenna, left a husband in Bowling Green, Ohio, and took her two daughters to Montana, where she worked as an itinerant school teacher, moving from district to district as schools opened and closed in response to changes in student populations. Glenna's daughter Thelma, Isobel's great-grandmother, grew up in log cabins before traveling east to become a nurse and the matriarch of an extended family of female descendants. Pryde, Isobel's grandmother, was an accomplished portrait photographer who gave life to five daughters: Laura, Sarah, Jennifer, Martha, and Joan. Eldest sister Laura, Isobel's mother, found her vocation in her mother's darkroom. Recently, she has been drawn to follow her great-grandmother Glenna's footsteps westward, using her camera to chronicle visual stories about time, both geologic and human. We often conceive of photography as a medium that captures and preserves a moment in time. Here, in a portrait of her daughter, Laura McPhee suggests it can also transcend time, linking generations.

G.M.

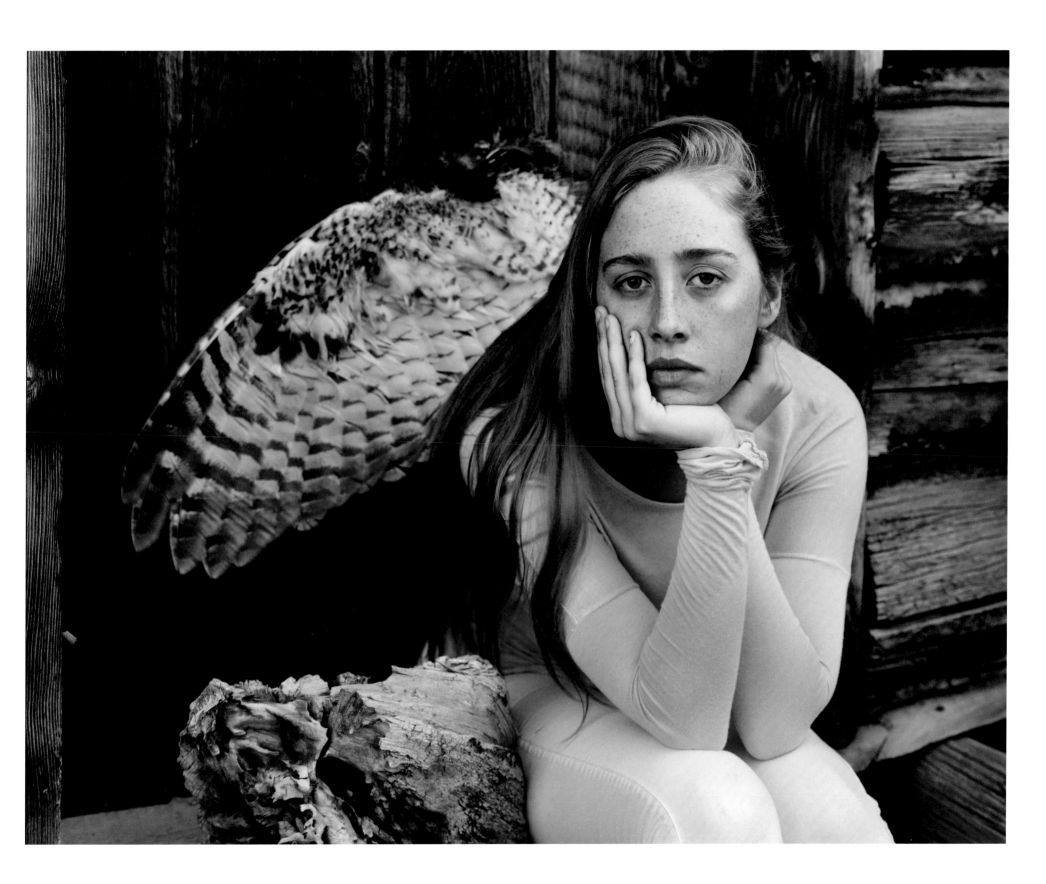

Kim Stringfellow *Bathers at Tecopa Natural Hot Springs,* Tecopa, California, 2016

The hamlet of Tecopa, known to desert travelers for its exceptional natural mineral hot springs, lies in an otherworldly realm of mud-encrusted badlands along CA State Route 127 at the eastern side of Death Valley National Park. Here is a timescape revealing the unfathomable passing of geological ages that is distinctly delineated in the photograph's mid-ground and beyond. Indeed, ancient tracks of mastodon, camel, and horses, extinct since the late Pleistocene epoch, are preserved in volcanic ash in Dublin Gulch in nearby Shoshone. Over the years Tecopa's rather spartan commercial spas have become popular, especially with vacationing Korean Americans who are known for their social bathing culture, and several of the spas located here are owned by Korean Americans.

For me, the photographer, this particular image suggests a positively grounded connection to the desert landscape, a literal immersion that many of us never find time to experience in our contemporary 24/7 culture. Other small visual details I enjoy in this image are the little bits of trash hidden in the reeds surrounding the pool. No matter how remote, we humans seem to leave our mark everywhere. As writer William Fox commented at the 2017 Desert X symposium in Palm Springs, "Desert reveals human intent on the land."

K.S.

Karen Halverson *Wahweap Marina, Lake Powell,* Page, Arizona, 1995

The first time I saw Lake Powell, I thrilled at the vast expanse of pale-blue water set against ancient sandstone cliffs. But I felt a sense of loss too, loss for something I had never seen. I knew that, where the lake now spread out before me, there once had been a magnificent canyon, one of many canyons on the Colorado River. Beginning in 1963, when construction on Glen Canyon Dam was completed, river water began flooding the canyon, creating the huge reservoir we know as Lake Powell. Glen Canyon lies buried deep below the lake's surface.

Lake Powell is named for John Wesley Powell who led expeditions down the Colorado River in 1869 and 1871. It is an enormous reservoir that, at full capacity, has a two-thousand-mile shoreline. The dam has been controversial ever since construction began. For more than fifty years, there has been talk among environmentalists of dismantling Glen Canyon Dam and draining the lake. Meanwhile, the dam generates electricity and prevents flooding, while delivering water to seven arid western states.

What was sacrificed in the service of "reclamation" is not visible in the photograph we see here. Not that the dam is a secret. In fact, it is just a few miles away. I certainly knew the history of Lake Powell on the day in 1995 when I made the photograph. But never mind, there was so much beauty to appreciate that day. The deep view was surely serene, with its clear blue sky, its calm waters, the raking, rose-hued light on the sandstone cliffs, and the bevy of houseboats inviting an excursion. Here was a glorious lake, set in a desert landscape. More like a miracle from on high than anything else. You'd hardly know from looking that anything had been sacrificed.

The near view in the photograph presents a different picture, at least superficially. The hand of man is much more apparent. The broad sidewalks, the tidy lawn, the modest hedge all create a sense of order and control. We're talking landscaping. To visitors coming from urban areas, the scene must have looked comfortable, even familiar, much like a small park or a private yard. But then there was the satellite dish, looming even larger than the sandstone cliffs. I had not seen it on previous visits to the lake. I found it particularly jarring, especially in its context. The suburbanized foreground, satellite dish and all, is clearly a human construct. But then, despite its sublime beauty, the lake beyond is a human construct too, and on a much larger scale.

Someone once said that the two critical decisions a photographer makes are where and when to trip the shutter. Obviously, I chose my vantage point so as to emphasize the satellite dish, exaggerating its size while also letting it burst the frame like the alien thing that it is. That much I remember. But looking at the image now, I see that my vantage point also sets up a formal relationship between the small hedge close by and the immense rock formation out yonder. That the hedge occupies more space in the image is a visual joke, just a trick of optical perspective. Yet one could also say the arrangement expresses, though perhaps unwittingly, my feelings about man's perennial drive to control nature. Who can say? It was a long time ago. As I have thought many times in my wanderings around the American West, sometimes I find beauty, sometimes desecration, often an absurd and perplexing combination.

K.H.

David Ottenstein *Keokuk Power,* Keokuk, Iowa, 2008

Architectural photography is as old as the medium. The oldest surviving photograph, made by Nicéphore Niépce in 1826 or 1827, shows the buildings and countryside of his estate at Saint-Loup-de-Varennes, France. Ever since, photographers have recognized that human constructions, from humble homes to urban skylines, embody our ambition and ingenuity, our vanity and accomplishments. Reflecting the aspirations of architects, contractors, owners, and communities, buildings, whether simple or majestic, have also proved to be malleable subjects that allow, perhaps compel, photographers to develop distinctive aesthetic approaches to recording their presence on the land.

The Keokuk power plant at Mississippi River Lock and Dam No. 19 is an engineering marvel. More than one million cubic yards of earth and rock were excavated when it was built between 1910 and 1913. Designed to take advantage of the extensive Des Moines Rapids which obstructed river traffic at Keokuk, the powerhouse, dam, lock, dry dock, and ice fender were constructed as a two-and-a-half-mile concrete monolith that spans the Mississippi. The dam, almost a mile long, is 53 feet high, tapering from a width of 42 feet at its base to 29 feet at its top. The rotor, turbine, and shaft assemblies for the plant's fifteen generators may be the largest ever built. After a century of virtually continuous operation, none of them has required more than minimal repair. Capable of generating more than 140 megawatts of electricity, the plant is estimated to save an average of 1,000 tons of coal per day of operation. The navigational lock, expanded in the 1950s, has served more than 15,000 loaded barges and 880 recreational vessels in a single year.

David Ottenstein's image depicts the main plant from Keokuk, looking northeast across the lock with a portion of the dam visible in the background. Illuminated windows at either end of the plant, perhaps lit by a setting sun, expand the dynamic range of the photograph, enhancing the subtle variation of gray tones throughout the image. Despite its massive size and complexity, the plant, mirrored on the placid surface of the lock, seems to float on the water that surrounds it. The power lines that crisscross the foreground converge on shore, coming together at a utility pole which reminds us that beneath the calm surface that surrounds the plant, roiling water is being converted into electricity sufficient to power 75,000 homes.

We have come to understand that dams have negative as well as positive consequences. The benefits of carbon-neutral energy are countered by silting behind the dam which has destroyed a population of pearl-bearing river mussels that once supported a vibrant button industry in riverfront towns. But at a time when Americans seem increasingly skeptical of investing in the infrastructure of our society, Ottenstein's image reminds us of the civic as well as engineering accomplishments of the Progressive Era. More than a hundred years after its construction, the abundant, inexpensive energy provided by the elegantly designed Keokuk power plant continues to transform the Iowa countryside hundreds of miles away.

G.M.

Kim Stringfellow *The Boneyard with Tehachapi Wind Farm,* Mojave, California, 2015

The great photographers of the nineteenth and early twentieth centuries taught Americans how to see the West. Visitors to Yosemite or Yellowstone seek the views consecrated by Carleton Watkins or William Henry Jackson. Schooled by Ansel Adams, travelers through New Mexico look for the moon, rising above an Hispanic village. As familiar as those scenes have become, they were once unseen, or perhaps un-scenes, until a photographer framed them for us. Having seen them, we take them for granted, failing to appreciate the artistic vision and technical skill required to conceive and capture them.

At first glance, Kim Stringfellow's photograph of four decommissioned commercial airliners at the Mojave Air and Space Port seems a simple if dramatic composition, one that would occur to anyone driving past the airport. A closer examination reveals how carefully she has composed a dense, complex image. Peer between the planes and see dozens of railroad container cars caught in transit. Consider how she arranges the wind turbines, which lie more than eight miles from the airport. They parade across the picture, parallel to the planes and train, while thrusting upward into the sky, anticipating the way the mountains rise from the desert floor.

Stringfellow found a vantage point, a time of day, and camera settings that allowed her to capture three of southern California's major industries, aerospace, railroads, and alternative energy, set against the full range of the Mojave landscape, from the sere-brown desert floor to wispy clouds floating above the brush-covered Tehachapi Mountains. In a single, compelling image she encapsulates much about the history and character of the region.

Mojave began in 1876 as a construction camp on the Southern Pacific Railroad. Located at the eastern end of Tehachapi Pass, it saw some three thousand Chinese laborers spend two years building tunnels and tracks through the pass to connect the San Joaquin and Mohave valleys and provide train services between San Francisco and Los Angeles. The rail line, which carries nearly forty trains a day, remains one of the busiest single-track lines in the world.

Mojave Airport opened in 1935 to serve local gold and silver mines. During the Second World War, the Marine Corps took over the field. It fulfilled various military purposes until 1961 when Kern County obtained its title. Today, it supports several dozen companies engaged in advanced aerospace design, flight testing and research, and airliner storage and reclamation. The dry desert conditions and open spaces make its "boneyard" a fit place for defunct airliners waiting to be scrapped or cannibalized for parts.

Tehachapi Pass funnels more than rail traffic; it sustains average winds over 11 miles per hour. The eastern end of the pass hosts nearly 4,800 wind turbines which together produce more power than any other wind development in the United States. These turbines produce enough electricity to meet the residential needs of 350,000 people.

Stringfellow shows us an image that we will not forget, a view that seems so obvious that it is easy to imagine that we have always seen it. Except we haven't.

G.M.

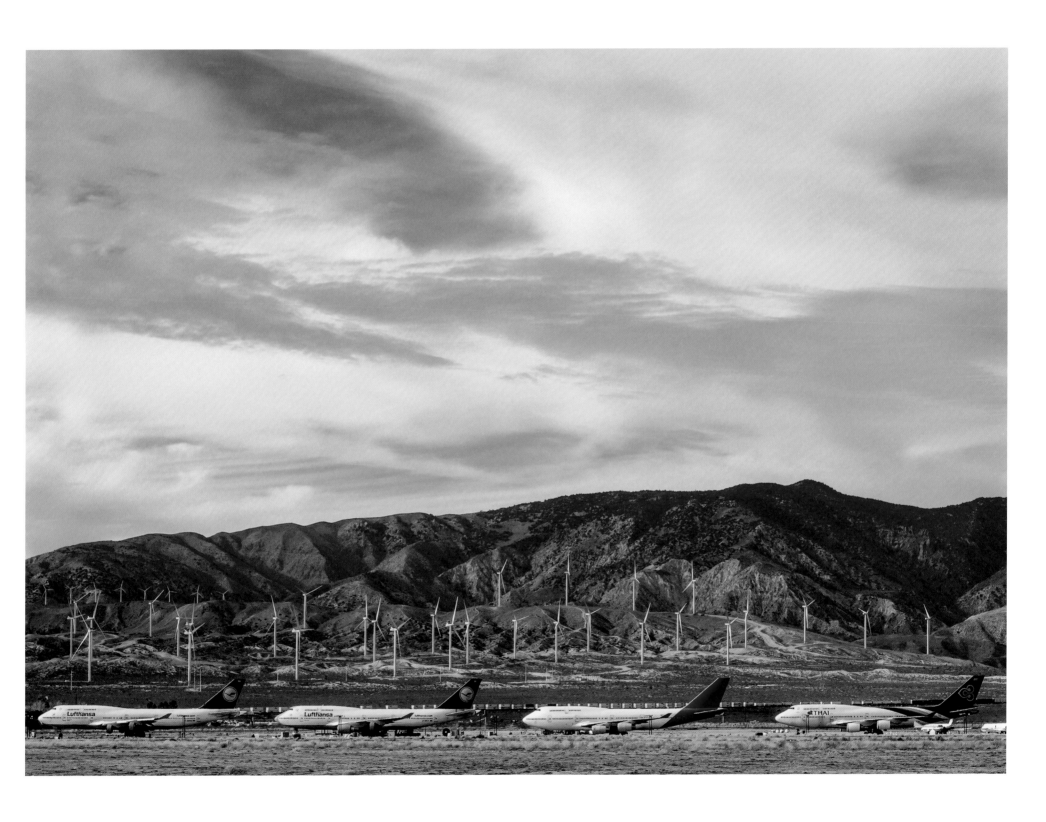

Marion Belanger *Fault 10,* Daly City, California, 2008

Daly City, located along a cliff overlooking the Pacific, is just
south of San Francisco. The city is the largest within San Mateo
County, and it is where the San Andreas Fault leaves the main-
land for the sea before it once again comes ashore near Stinson
Beach. Here, the Fault runs along the base of the cliff; modest
homes are perched at the top of the cliff where an active land-
slide periodically takes down dirt, rock, and the occasional
home. Yet the view of the Pacific is stunning, and for those who
live here the benefits of living upon the Fault more than eclipse
the all-but-certain risks.

M.B.

Marion Belanger *Three Hunters with Swans,* Bear River Bird Refuge, Utah, 2003

Marion Belanger's photograph of three successful swan hunters abounds with contrast. A deep green hunter's pullover and three bright white swans jump out against the somber gray sky and the pale-brown grass growing along the slate-gray water. The hunters' vitality and exuberant smiles sharpen our recognition of the limp, lifeless birds they hold. Full of beauty, the photograph is disquieting; it draws us to contemplate the cost of the hunters' celebration. In so doing, it explores a pervasive, persistent theme in the history of the American West: the tension between preserving and using natural resources.

The unease or ambivalence we feel in looking at the image may be heightened when we realize that the image was captured at the Bear River Migratory Bird Refuge in Utah. The refuge comprises nearly 75,000 acres of marsh, open water, uplands, and alkali mudflats, southwest of Brigham City, where the Bear River flows into the Great Salt Lake. The U.S. Fish and Wildlife Service describes the refuge as a "wetland oasis in a desert for wildlife and a wild oasis for people...set aside to conserve America's fish, wildlife and plants."

This vibrant ecosystem nearly died in the 1920s. Irrigation projects diverted so much Bear River water that the wetlands shrank to a few thousand acres. The reduction created detrimental overcrowding among the birds that visited the wetlands. Avian botulism killed two million birds in 1910. Ten years later, 1.5 million more died. In 1928 Congress responded by designating the area a National Wildlife Refuge. The government and local citizens built fifty miles of dikes and canals to restore 25,000 acres of wetland. Located along the eastern edge of the Pacific Flyway and the western edge of the Central Flyway, the refuge serves as a resting, feeding, and nesting area for more than 250 species. Millions of individual birds migrate through the area annually; sixty-seven species nest there.

The refuge also hosts nearly 50,000 human visitors each year. While many observe wildlife from a twelve-mile-long road through the refuge, others fish and hunt, continuing practices which developed in the nineteenth century. The tension between preservation and use, an enduring feature of the West, is now built into the landscape; the territory around the refuge hosts multiple hunting clubs.

Tundra swans, like the ones shown in Belanger's photo, feed and rest in the refuge during their migration between breeding grounds in the Arctic and winter homes in California. Their size, beauty, and relatively short visits to the inter-mountain West make them top trophy birds of the fowling world. The U.S. Fish and Wildlife Service regards their population of some 170,000 as sufficient to support regulated hunting. Utah's Division of Wildlife Resources requires that prospective hunters complete a training session and limits them to taking one bird per year. The state, which receives between 6,000 and 7,000 applications, usually issues about 2,000 permits per year. For three hunters at least, the result appears to have been worth the process. The swans are silent.

G.M.

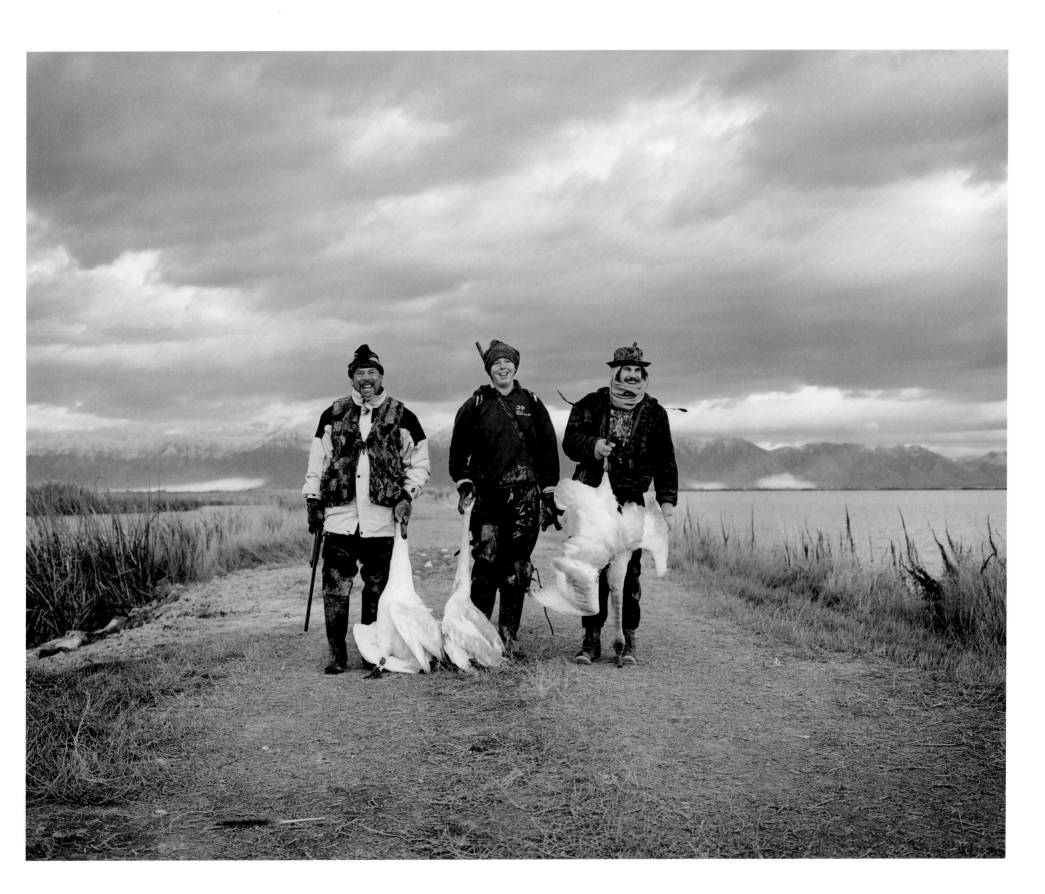

Richard Buswell *Raptor Skeleton,* Montana, 2007

The relationship between the objects an artist photographs and the images he creates has occupied critics since the invention of the medium. In *Looking at Photographs* (1973), John Szarkowski observed:

> The object [of a photograph] is raw material, not art, and it is the nature of the artist's adventure to recast this material under the pressure of his own formal will, transforming it into something distinct from what it was. Nevertheless, his choice of the particular dross that he will spin into gold is an important matter, for his raw material is both his collaborator and his adversary.

More than forty years ago, Richard Buswell chose the relics of Montana's past as his raw material. In abandoned mines, ranches, and homes, he found the stuff on which to train his lens. Over time he sharpened his focus, moving from panoramic vistas of abandoned buildings amidst enduring landscapes to meticulously composed depictions of natural and man-made objects against stark black backgrounds, absent external referents. In so doing, he shifts our attention from the purpose or utility of his subjects to the form and structure of his pictures. Rooted though they are in Buswell's experience as a life-long Montanan, his photographs are no more (nor less) "about" Montana than James Joyce's *Ulysses* is "about" Dublin.

Raptor Skeleton highlights the formal beauty that Buswell creates from his re-discovered remains. A tight frame and the limited spectrum of a black and white print pare the skeleton to its formal core. A sharply defined splay of spiny white cartilage supports two grey ovoids, an eye-socket and a beak, surrounded by fine wisps of what appears to be hair. That such a solid, hefty object could emerge from and be supported by such fragile filaments is as beautiful as it is improbable.

Most photographs of Western ghost towns and historical artifacts abound in sentiment. Manipulating our nostalgia for bygone days, they comfort us with the illusion that we can turn back and recover what has been lost. *Raptor Skeleton,* like Buswell's other "still lives," confronts us with beauty that spurs us to measure our days. It reminds us that time is relentless and remorseless, a current that carries us forward despite our wishes to remain or return. Richard Buswell is not a morbid man, but neither is he an escapist. His meditations on Montana's relics are complex, equally tender and harrowing, intimate and accessible.

G.M.

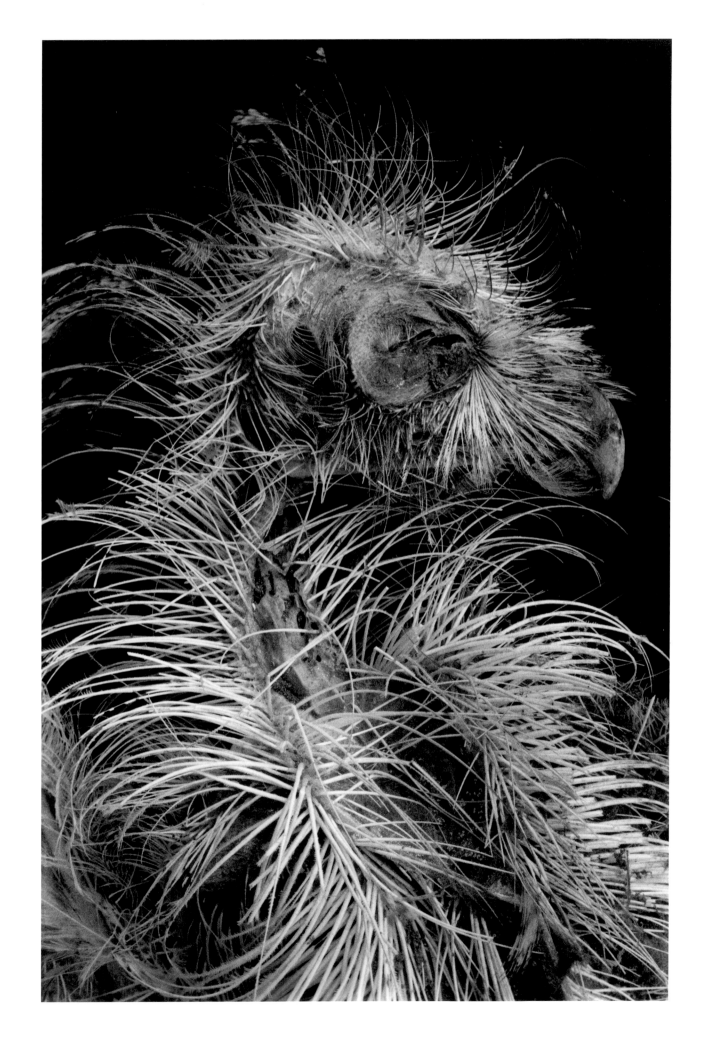

Lauren Henkin *Clearcut,* Oregon, 2008

In 2008, I moved to Oregon after spending most of my life in Washington, DC. I had visited California once, decades earlier, but I did not know what to expect from the Pacific Northwest.

The photographs I make primarily focus on our relationship to place and space. After my move west, I became more aware, more connected to Nature, and overwhelmed by the persistent rain and smell of dampened earth. The constant moisture created shades of green I had never seen before, hundreds of rich variations of hue within one color that after looking long enough, became millions. While I didn't know that nearly half of Oregon's acreage is forested, I could sense the will to grow, to reclaim, to replicate that was driven by the unrelenting drip, drip, drip.

As an artist, I care more about raising questions than answering them. In the making of this photograph, I held true to this principle and yet its impact and meaning cannot be abstracted. The photograph was made on a drive between Portland and the Pacific along Route 26. In aerial photographs of this area, you can see swatches of brown, patches of land that have been clear-cut. Standing in these vast terrains, it is deathly quiet and void of so much of the life present in Oregon's forests. The experience of being there, surrounded by stumps, has haunted me ever since. The only comparison I can think of is to imagine oneself inside a Matthew Brady photograph made during the Civil War. It feels like loss, the earth dank.

What makes this photograph important to me is that, while the viewer can clearly discern that this is a scene where some act of violence has occurred, there is also a surprising renewal of life. The rain encourages rapid growth, covering limbs and debris fallen during the cutting. Here, weeds are welcome—anything with the color of life to replace a decimated landscape.

L.H.

Lauren Henkin *External 5,* from the series *Growth*, Oregon, 2009

In the middle of the twentieth century, from the 1930s through the 1960s, amidst a rising concern for preserving portions of the West from industrial and commercial development, Western landscape photographers generally focused on scenes of natural grandeur that existed beyond human interference. The photographer and viewer were privileged visitors to extraordinary places they neither shaped nor inhabited. Photographs captured a transcendent beauty which offered a respite from the disquieting aspects of industrial life and elevated our appreciation of timeless spaces which ought to be revered and protected.

While photographers such as Ansel Adams, Edward Weston, and Elliot Porter drew heavily on the themes and visual tropes of their nineteenth-century predecessors, they tended to ignore the ways in which their predecessors engaged not only with the austere beauty of newly discovered places, but also with the ongoing process of transforming such spaces. They followed Carleton Watkins and William Henry Jackson into Yosemite, Yellowstone, and other undeveloped places, but rarely joined them when they documented railroads, farms, and urban spaces.

In the 1970s, photographers Edward Ruscha, Robert Adams, Lewis Baltz, Stephen Shore, and others turned away from grand landscapes. Instead they explored prosaic aspects of the built environment, suggesting that photography's power and purpose were better served, not by showing us extraordinary places, but by compelling us to re-examine our daily landscapes and confront our role in making the world we inhabit.

In her image of a picnic table overcome by an aggressive vine, Lauren Henkin frames a mundane scene in a way that provokes us to reconsider the character of our relationship to nature. Our initial response might be to regard the vine as an invader disrupting the order of a rural or suburban homestead. Prolific but undisciplined, the tangled stems of the vine threaten not only the picnic table, but also the domestic recreation it represents. Seen against the stand of pine trees across the street, however, the vine seems less interloper than resilient survivor reasserting the natural order. The vitality and vibrancy of the fecund vine contrast with the bland, undistinguished home behind it. Drawn curtains transform a window into a barrier, isolating the residents of the home from the scene, suggesting their ignorance and indifference to what is unfolding in their yard. Perhaps the building itself is destined to be overtaken by the growing world outside.

Henkin's image is less didactic than provocative. It doesn't propose an answer; it does ask us to open our curtains, look closely at what is happening around us, and consider the implications of what we see.

G.M.

David Ottenstein *Abandoned House, 510th Avenue, Poweshiek County*, Iowa, 2009

This picture was made in 2009, five years into my project photographing the vanishing architectural landscape of the single-family farm in Iowa. The subject here—a crumbling, abandoned farmhouse and a lone, leafless tree in a cold winter landscape—perhaps evokes, for some, sadness over the loss of the agrarian landscape of which this farmstead was once a vital part. For me, the picture speaks to the character and personality of the architectural remnants of this vanishing era. Even in its state of decay the house resides proudly in the open landscape, marking what was certainly once a complete farmstead with barn, corncrib and other buildings in addition to a windmill, fence, part of which remains, and most likely, additional trees serving the dual purpose of shade and windbreak.

The photograph describes a space, typical in much of my work in Iowa: broad, open, occasionally flat, but more often set on rolling hills. The space is inhabited now by the *remains* of an agrarian chapter in American history—one spanning from the mid-nineteenth century and peaking in the mid-twentieth, followed by a steady decline that began not long after World War II. This agrarian landscape continues to exist side-by-side with contemporary elements of industrial agriculture. I'm drawn far more to the fading wooden buildings—grain elevators, corncribs, barns, farmhouses, churches and schoolhouses—than I am to the engineered metal structures that house large farm equipment, ethanol plants, hogs and chickens by the hundreds of thousands, or the sleek towers and spinning blades of the now ubiquitous wind farms, all of which, collectively, represent the new landscape of industrial agriculture. I'm compelled by the subtle beauty of this place and by the challenge of making strong photographs in a landscape that resists the necessity to frame or contain it.

The photograph feels to me to be entirely consistent with other pictures I made in the first several years of the project when I was working exclusively with a 4 x 5 view camera and shooting film. However, this picture was produced digitally and utilized the made-for-digital technique called HDR (high dynamic range). I made multiple images at different exposures and stacked the images to produce a finished photograph with a tonal range wider than a single exposure would have allowed. (It is now a common technique, incorporated as a simple setting in smart phones and amateur-level digital cameras, but was then, and continues to be, a powerful tool for controlling contrast and expanding creative photographic possibilities.)

Contemplating this photograph eight years after taking it and some 14 years into my "Iowa" project, I'm struck by how it marks my transition from film to digital. Bringing to it what I see on paper and what I know of its origin, it feels like a hybrid image. Like the 4 x 5 view camera—which *required* the use of a tripod—the digital camera in this case was *by my choice* on a tripod and the aspect ratio was set for 4 x 5 rather than the camera's native 35mm frame (a longer rectangle with 4 x 6 aspect ratio). The picture looks as though it could have been produced on 4 x 5 film; it has the stillness and deliberate quality that always characterized my view-camera work. But by using a digital camera I was able to take advantage of new techniques that have gradually expanded my possibilities and productivity as a photographer. And, as digital sensors have improved, resolution has increased, and processing software has evolved, I have been able to produce more work with increasingly precise control over the finished print. So this image reminds me of my departure from my roots in large-format film photography and my adoption of a new set of photographic tools.

D.O.

Richard Buswell *Silo,* Montana, 1996

In the summer of 1996, I photographed the interior of a long-abandoned silo. Although the silo was never a sacred place, the suffused light from the top bathed the interior, somewhat akin to cathedral lighting. The circular walls and vertical ladder led my eye to the top, where the roof balanced precariously. Splinters of leaking sunlight dappled the roof and walls. As I looked straight up to focus my camera, the concentric swirls of the walls left me dizzy. These were the aesthetics that attracted me to this image.

The silo was not on the way to anywhere. It stood by itself—an isolated beauty—among miles of land that was unpeopled. The country contained nothing but itself and the silo. Sagebrush had reclaimed a once-cultivated field adjacent to the silo. Places where farm buildings had once stood were just scars on the land. Brutal winters and baking sun had scrubbed the color from the siding, leaving the wood a mousy gray. Tumbleweeds were stacked on the windward side, their stampede temporarily halted. Some clawed at the cracks in the wall trying to get inside. The clacking of grasshoppers was the only sound that I heard.

As I squeezed through a break in the walls to access the interior, there was a sea of movement. The silo was so dark inside that I needed my night eyes. For decades the silo's purpose had been to store grain and silage. Once abandoned, it hosted only the sky, pigeons, rodents, and flies. Pigeons flushed with frenzy as I entered. Rodents scurried silently along the periphery, stopping occasionally to take stock of my whereabouts. Flies, both purple and black, darted through dust-filled strips of light. They also clouded around my head, taunting me to swat them. Spiders coveted the darkest nooks, with dead flies and moths

suspended from their webs. The silo's concrete pad was splotched with orange lichen and fuzzy moss. Droppings from all the critters were nearly ankle deep. The smell was strong and full of dank. I could taste the smell. Breathing seemed risky. I exposed my negative and got out of there.

Twenty-one years later, in the summer of 2017, I revisited the silo. Its roof had collapsed into a heap of lumber, and its walls were caving. It was close to giving up. The barely standing remnants shivered in the rakish winds. Those strafing winds have drained its strength as it tilts away from the frequent gales. The remaining walls creaked and moaned with every gust. Mauling winters had added to the decay.

I slipped inside through the same crack in the walls that had let me enter before. Daylight filled the interior where once the sky only trickled in. Spiders needed to search harder to find a darkened space. The droppings on the concrete floor were deeper than they had been before. The smell still made me gag. There was a new generation of pigeons, vermin and flies, but their behavior was still the same.

Time and weather had taken their toll. The outcome is pre-determined. No grand coda will announce its demise. The silo will finish its collapse and die without ritual. No longer will it be the proud icon on the landscape.

Since I photographed the silo in 1996, I too have weathered. My steps are slower and closer together. The silo and I are entering the last chapter of our lives. What my memory forgets, my photographs will usually recall. Such is the case with *Silo*.

R.B.

David Plowden *Union Pacific Railroad Crossing near Clare, Iowa, 2011*

This picture is among the last photographs I made. In June 2011, my wife Sandra and I left our home in Winnetka, Illinois, to begin what turned out to be my final trip in the field. After sixty years of making photographs across North America, I wanted to revisit the prairies of the great Midwest, a terrain that had become a second home after Sandra and I settled north of Chicago in 1978. When we set out that morning, I was scouring a countryside that I had come to know so well. Shortly before noon, I encountered a scene that compelled me to stop. There, in one place, the many strands of my career were brought together.

For as long as I can remember, I have been fascinated by steam locomotives on American railroads. They were awesome, immense, mirroring the energy and ingenuity of America. For fifteen years I photographed nothing else. My earliest photographs were of the trains that ran through northern New England near Putney, Vermont, where my family had a farm and I attended boarding school. As an undergraduate at Yale, advised by a phalanx of uncles, I dutifully studied economics to prepare for a career on the railroad. But my love of steam locomotives and the railroad had nothing to do with managing a company. After a blissful year "riding the rails" as a new employee, I came to work one morning to find that I had been promoted, headed for a life fettered to a chair in the company's St. Paul headquarters. So I quit. What was I to do? Why not photography, which I loved and through which I could try to deal with the immensity of my new-found American landscape, a task that I have wrestled with ever since. I had no real experience, just a passion for what I saw. I turned to the some of our greatest photographers, Minor White, Nathan Lyons, O. Winston Link, and particularly Walker Evans, to help me turn a personal passion into a vocation.

I left the railroad business in 1956, but trains had introduced me to America. In 1962 I started my photographic trips through the West, by car. I photographed by day and developed film in motel bathrooms at night. My first wife, Pleasance, and I made four summer-long camping expeditions into the field with two kids, once with both in diapers. One year, while returning east, I paused on the rim of the Rockies. Looking across the Great Plains spreading out before me I imagined seeing the curve of the earth. Maybe I did. I came to understand what Willa Cather meant in *Death Comes for the Archbishop* when she wrote, "Elsewhere the sky is the roof of the world, but here the earth was the floor of the sky."

On June 21, 2011, after more than fifty years in the field, the various threads of my career suddenly came together outside Clare, Iowa, where the Union Pacific Railroad crossed a section road. The road and the tracks stretched to infinity, extending in all directions from whence I had come to where I was that day. The roiling, angry sky not only reflected my response to the many changes I had seen in America, but also provided the exciting, turbulent, stormy light with which I have always preferred to photograph. I had come upon this place by chance, where all the elements necessary to make a photograph of mine aligned. I had not known that I would find this picture at that crossing, but it struck me then, and now, as an apt conclusion to my photography of the American heartland.

D.P.

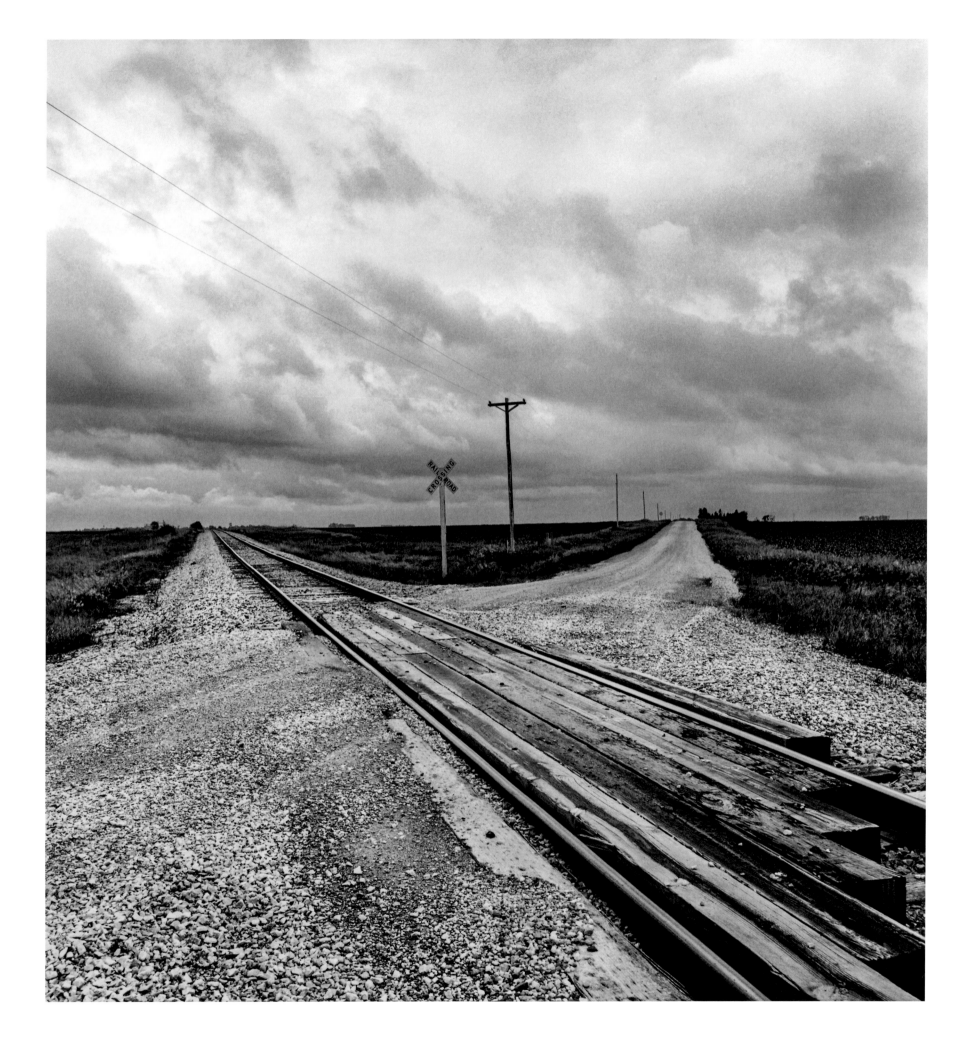

John Willis *Door Trail, Badlands National Park,* South Dakota, 2012

Although nineteenth-century photographers frequently depicted people visiting scenic sites and newly created national parks, for much of the twentieth century, the inclusion of people in photographs of park lands was relegated to family photo albums and pamphlets promoting park services. More often than not, mid-century American photographers elided signs of human presence and emphasized the way that parks revealed and preserved "deep time." Their beauty and power lay in their enduring, almost timeless qualities that made quotidian concerns seem petty.

Perhaps unwittingly, such work reflected the perspective of the National Park Service whose mission is "to conserve the scenery and the natural and historic objects and the wild life" of the parks "in such manner and by such means as will leave them unimpaired for the enjoyment of future generations." An unspoken goal was to assure that our grandchildren would enjoy virtually the same experience of the Grand Canyon, Yosemite, or Yellowstone as our grandparents once had. That noble aspiration is a glory of the Park System, but it carries the risk of sterilizing our encounter with the natural world. "Take nothing, leave nothing" can be a reasonable reminder that we are tenants not the owners of the world we inhabit, but it can also reduce us to spectators, to observers isolated rather than engaged with the world around us. We visit the parks to confirm the images we have seen in photographs.

If the grand landscapes of mid-century had an unintended consequence of pulling people out of nature, more recent work has found the theme of people interacting with our parks ripe for exploration. Such photographs juxtapose the contemplation of deep time, epitomized in John Willis's image by the vibrant geologic strata of Badlands National Park, with the more immediate story of the seven people walking through the park. Who are they to each other, to us? How long have they been walking through the park? Their clothes and headwear suggest they may be members of a Hutterite or Mennonite community, committed to communal life and the preservation of values developed centuries ago amid the tumult of the Protestant Reformation. Does the conservatism of their culture inspire a greater appreciation of the geologic history preserved in the Badlands? Do they know that Native Americans lived in the Badlands as much as 11,000 years ago? Are they aware that a portion of the park was taken from Lakota residents of Pine Ridge Reservation by U.S. Army Air Force for use as a gunnery range during the Second World War? Will they carry enduring memories of their visit to the park?

Willis provides no answers, but his decision to include the family transforms his picture from what might have been a traditional scene of Western wilderness into a richer exploration of our complicated relationship with nature, in and out of our national parks.

G.M.

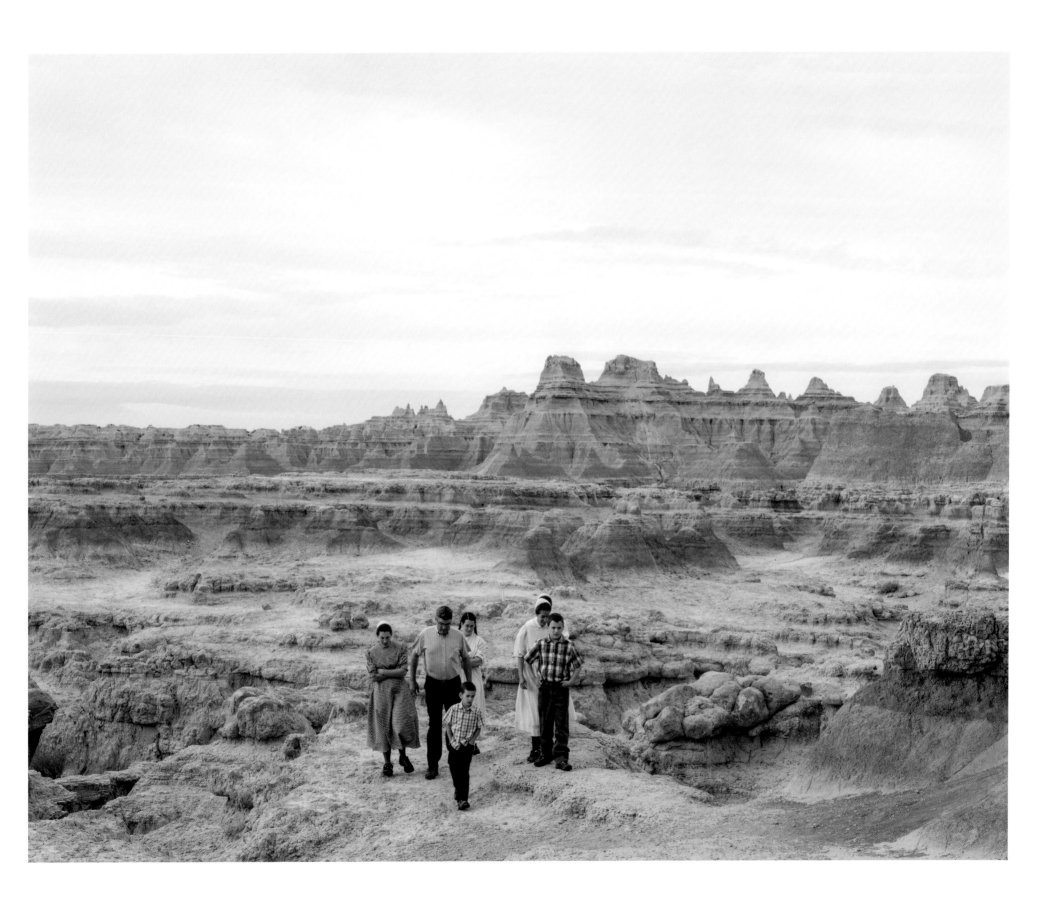

Miguel Gandert *Musicos y Santos* (Musicians and Saints), Picuris, New Mexico, 1995

I made this image while working on *Nuevo Mexico Profundo,* a survey of Indo-Hispano communities along the Rio Grande corridor from northern New Mexico to Juárez, Mexico. While I primarily focused on the Hispano villages, I realized the importance of representing the confluence of indigenous with Spanish/ Mexican communities and their Pueblo neighbors, a relationship that has continued for more than four hundred years. I selected the Tiwa community of Picuris in northern New Mexico. Located in the heart of Sangre de Cristo Mountains between Taos and Santa Fe, Picuris is the smallest of New Mexico's pueblos. It is surrounded by a number of Hispano villages.

Picuris always had an important place in my life. Growing up in Santa Fe, my nextdoor neighbors, the Yazzas, were a Picuris family. The close relationship I had with them and their extended family made Picuris a natural choice.

This picture was taken during the Picuris mid-winter dance celebration that takes place on Christmas Eve and Christmas Day. The "Dance of the Matachines" is staged in both Hispano villages and indigenous pueblos throughout New Mexico. Featuring the same characters, costumes, music, and choreography no matter where it is performed, the dance symbolizes the common traditions shared among Hispano and native American communities. It exemplifies the Indo-Hispano heritage of New Mexico.

A deeper reading of the image reveals a wealth of information concerning the strength of tradition in Picuris. The photograph was taken in *San Lorenzo de Picuris,* a mission church, which has been, and continues to be, an important spiritual center of the community. Picuris is believed to have been occupied since 1250 CE; in the sixteenth century it was one of the largest indigenous villages in the Rio Grande Valley. The Catholic mission was established by Spanish Franciscan monks who arrived with Spanish/Mexican settlers led by Juan de Onate in 1598. It is thought that the first church and convent were completed by 1629.

During the pueblo's history the mission has been destroyed and rebuilt numerous times, including during conflicts with Spanish Mexicans as well as with the Comanche Indians. In the 1960s the church was excavated and in the late 1980s the Pueblo rebuilt the mission on its original footprint, using traditional adobe materials; it now appears much as it did in 1778.

On the right of the image is a table with two *santos* dressed in traditional ceremonial skirts. The male figure has a crucifix around his neck and the female holds a rosary, symbols of Indo-Hispano confluence.

The two musicians are playing a guitar and a violin, traditional European instruments, although the majority of native dances are accompanied by drums, rattles and vocables. The church, the matachines, the music and the *santos* are all symbols of the links between the new and old worlds.

However the most important element of the image is the child between the musicians, who represents the belief that the dance and its fidelity to the past will continue well into the future.

M.G.

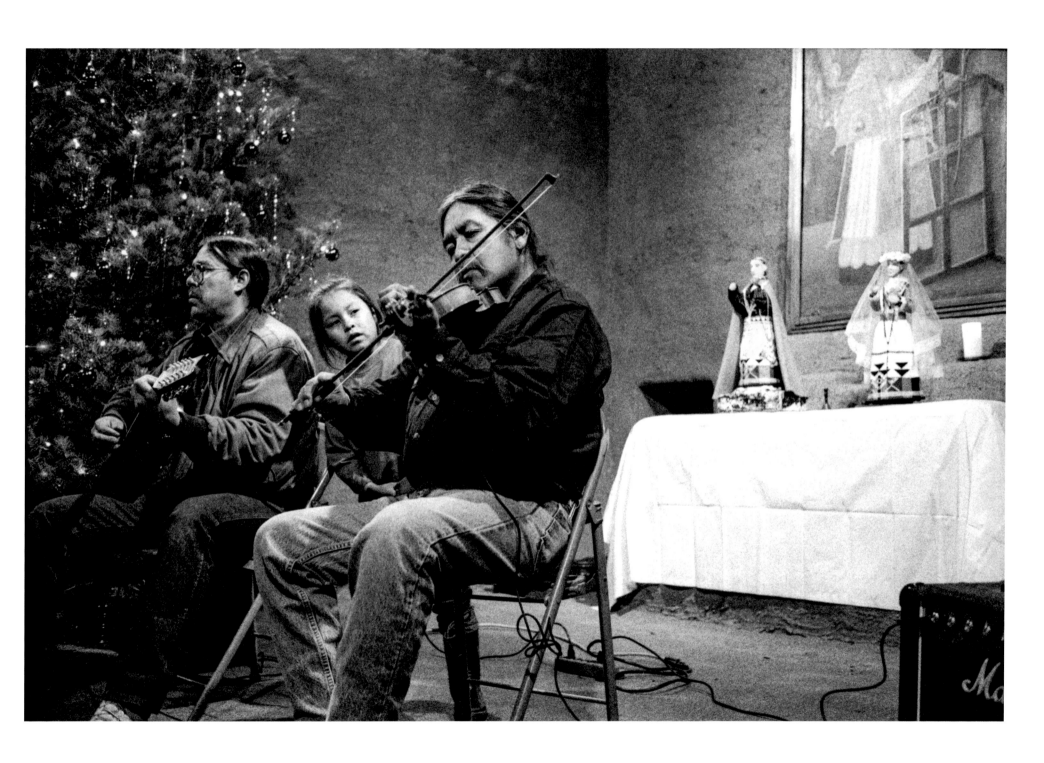

Owen Luck *Raven (Yaahl) at Eagle Clan Long House by James Hart* [Stastas Eagle Clan], *Old Masset, Haida Gwaii,* British Columbia, 2013

Looking at Own Luck's photograph of a lone raven, flying through the fog outside an Eagle Clan long house at Old Masset, it is easy to appreciate the bird's cultural significance. Among the indigenous communities of the Pacific Northwest, Raven represents the chaotic but transformative power of life. In their stories and legends, he is the being who changes things, sometimes intentionally, often by accident. In his constant pursuit of food, Raven creates unintended consequences, sometimes benefitting mankind, often causing mischief. Stories relate how he created the land, released people from a cockle shell, and brought them light and fire. But he also fills their boats with excrement. Sleek, powerful, independent, undomesticated, he is the generative force behind the world.

The spiritual power of Raven is recognized and respected by Northwest Coast artists who incorporate his form (and his disguises) in their woodwork, weaving, painting, and silver goods. That Luck was able to capture this image of a raven outside a long house built by James Hart seems especially apt. As an apprentice to Bill Reid, one of the most significant Haida artists of the twentieth century, Hart's first major project was to assist with Reid's *The Raven and the First Men,* a wood sculpture carved from a block of laminated cedar that measured eight feet by eight feet by seven feet (Museum of Anthropology, Vancouver). The work took two years to complete.

Hart, who was born in Masset, is the great-great-grandson of Charles Edenshaw, renowned Haida leader and artist of the nineteenth century. Hart escaped the Canadian Indian residential schools that many of his contemporaries were forced to attend. He grew up in Masset and became a fisherman. Hart developed a passion for Haida art in high school, and trained with Robert Davidson as well as Bill Reid. He is a jeweler and print-maker as well as a carver and has become one of the first Haida artists to explore traditional themes in bronze.

As a hereditary chief of the Eagle Clan, Hart has also taken responsibility for constructing clan long houses and raising poles at several locations on Skidegate Island. His work is part of a dramatic renaissance of traditional art throughout the villages of the Haida Gwaii. Since 1969 when the Canadian government abandoned a nearly 80-year-old ban on raising poles, more than a dozen new poles have been raised.

Raven flies and transformation continues.

G.M.

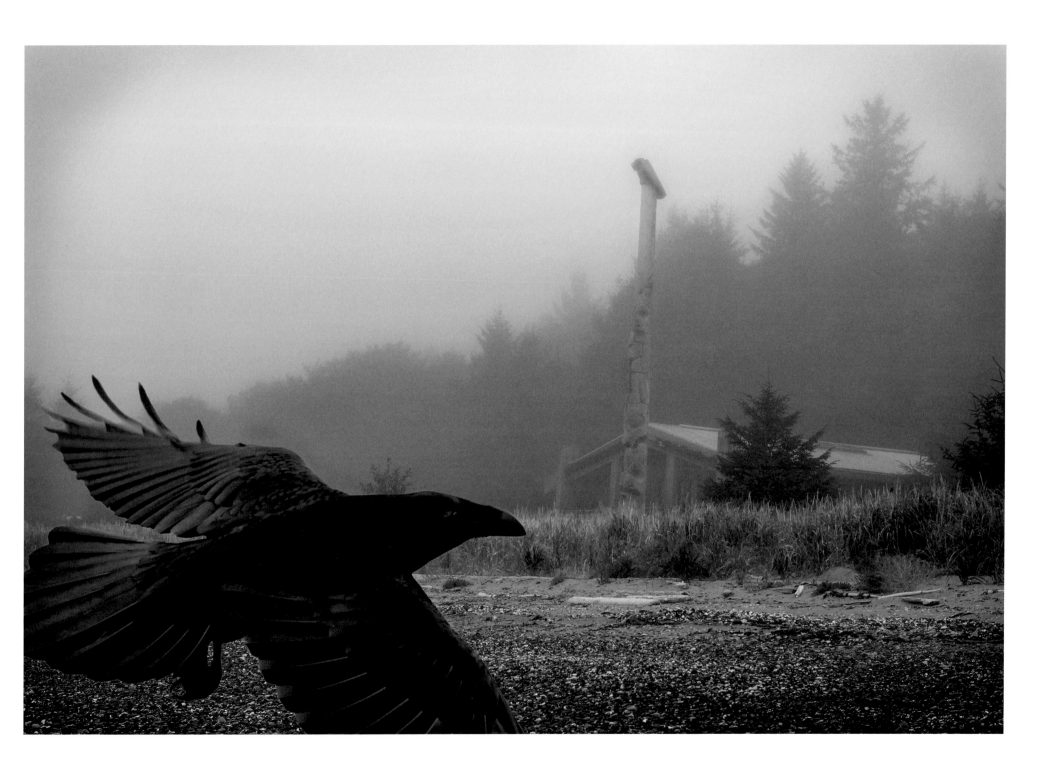

Toba Pato Tucker *Alaska, The Inside Passage ~ Icy Straight – Excursion Inlet,* Excursion Inlet, Alaska, 2015

The sea was an especially challenging subject for nineteenth-century photographers. The photo-sensitive emulsions of the time could not capture sea and sky in a single exposure. The time required to make a striking image of the sea blew out the sky, rendering it a blank expanse. The much briefer exposure which could depict clouds and a range of tones across the sky left the sea underexposed, a uniformly dark void. Frenchman Gustave Le Gray and Englishman Henry Stuart-Wortley perfected techniques to overcome these limitations, but few American photographers of the nineteenth-century West ventured beyond images of the shoreline and the ships that plied its coastal waters. Not surprisingly, while our mental image of the West is full of mountains and canyons, of forests and farmlands, of railroads and cities, we struggle to imagine what life on the water might have been like, or to appreciate the ocean as a source of life and culture.

For residents of the Pacific Northwest, life has always relied as much upon the sea as the land. From Puget Sound to Glacier Bay, thousands of islands, the tops of submerged coastal mountains, create a marine environment distinct from the open seas of the North Pacific and the fresh-water rivers of the mainland. The deep channels and fjords which separate the islands also provide for sustenance and communication. Indigenous communities have traveled, fished, and hunted the waters for centuries; European and Asian immigrants have adopted similar social and economic pursuits, relying on seaplanes as well as boats for transportation. The "Inside Passage," as it has become known, is one of America's great economic and cultural throughways.

Toba Tucker's seascape introduces us to this less familiar Western environment. It makes visible the expansive sea as well as the rugged, forested coastlands which abruptly emerge from it. Excursion Inlet is a narrow, fjord-like arm of Icy Strait, a forty-mile-long body of water that flows along the northeast coast of Chichagof Island, the fifth-largest island in the United States. Excursion Inlet is also the name of a census-designated place (CDP) on the eastern side of the inlet. The CDP, originally an Alaska Native village, had twelve permanent residents in 2010, but it has hosted a seasonal fishing cannery since 1891. A plant constructed in 1918 still functions today; it remains one of the largest seasonal canneries in the world.

Tucker is more interested in the sea itself than the economy it sustains. While the snow-capped mountains in the background may be what we first notice, our attention is soon drawn to the surface of the water where she translates the rhythmic, three-dimensional wake created by her ship into a two-dimensional tone poem, in which lighter and darker shades of gray shimmer to the edges of the frame. The towering mountains peak and give way to the sky; the sea flows ever outward, an invitation to travel and adventure.

G.M.

84

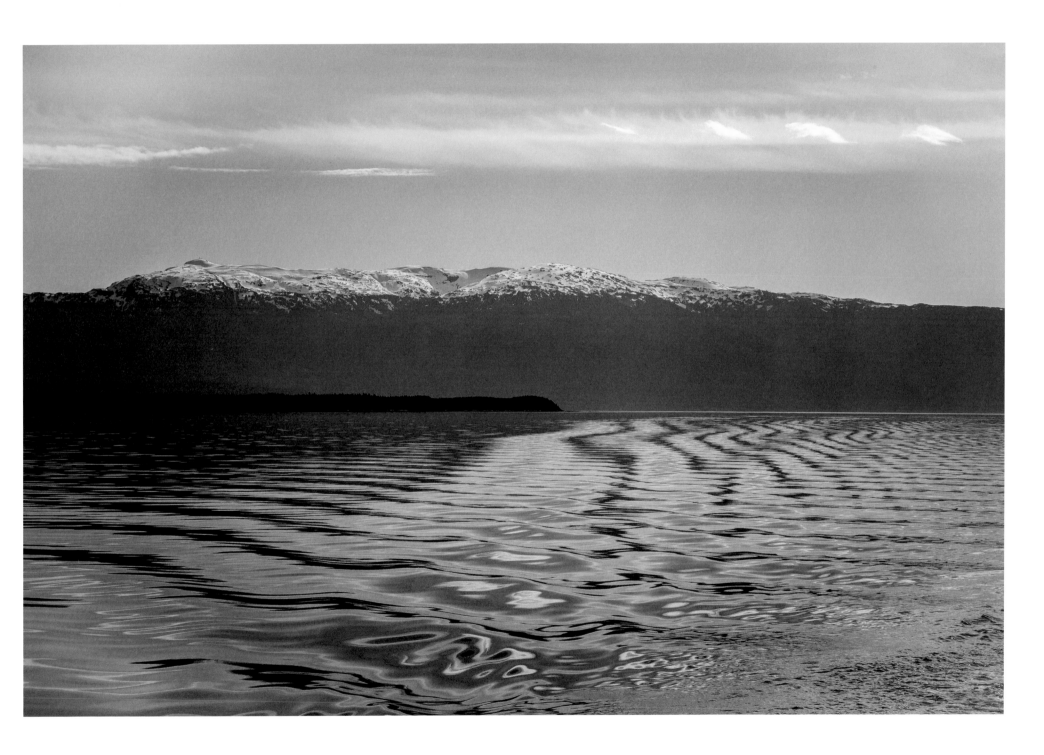

Artists' Biographies

Abraham "Abe" Aronow (b. 1940)

Born in Brooklyn, New York, Abe Aronow was raised in New Haven, Connecticut. He earned a Bachelor of Science degree from Massachusetts Institute of Technology and a Doctor of Medicine from Harvard Medical School. He served as a physician in San Francisco from 1969 until his retirement in 2007. Aronow learned photography from his father and pursued the art at the encouragement of one of his patients, Ansel Adams. In 1981 Adams introduced Aronow to members of Group f/64 and other photographers; the meeting inspired Aronow's multi-decade project to portray contemporary photographers, artists, musicians, and scholars. Aronow has also photographed on the streets of San Francisco, documenting its diverse community, and captured scenes across the North American West from Arkansas to Oregon. Significant collections of his photographs are held by the Beinecke Library, the Stanford University Library, and the Harry Ransom Center at the University of Texas at Austin.

Marion Belanger (b. 1957)

Marion Belanger photographs the cultural landscape, particularly the intersection of geology and the built environment. Belanger received a Bachelor of Fine Arts from the College of Art & Design at Alfred University and a Master of Fine Arts from Yale University. In *Everglades: Outside and Within* (Center of American Places, 2009) she explores not only the wetlands of the current national park but also the ways in which Americans have drained, occupied, and developed the surrounding land that was once part of the Everglades. *Rift/Fault* (Radius Books, 2016) depicts the land-based edges of the North American Continental Plate along the San Andreas Fault and the Mid-Atlantic Rift. The recipient of the 2017 Shpilman International Prize for Excellence in Photography, Belanger has been collected by the National Gallery of Art, the Library of Congress, New Orleans Museum of Art, Yale University Art Gallery and the Beinecke Library.

Richard Buswell (b. 1945)

A fourth-generation Montanan born in Helena, Richard Buswell learned photography working for *The Nugget*, Helena High School's student newspaper. In 1971, a year after completing a medical degree at Oregon Health Sciences University, he purchased a 35mm Nikkormat that he continues to use today and began photographing abandoned towns, mining camps, and homesteads across Montana. Inspired by Georgia O'Keeffe, Buswell crafts images that present and contemplate the abstract qualities of decaying bones, corroded artifacts, and dilapidated buildings. In 1997 the University of Montana published his first book, *Echoes: A Visual Reflection*. Since then Buswell has published five more books including *Close to Home: Photographs* (New Mexico, 2013) and *What They Left Behind: Photographs* (New Mexico, 2017). In addition to the Beinecke Library, his images are held by the Smithsonian American Art Museum, the Corcoran Gallery of Art, the Montana Historical Society, and the George Eastman Museum.

Miguel Gandert (b. 1956)

Born in Española, New Mexico, Gandert grew up in Santa Fe. As a teenager he began photographing the people and places of the Rio Grande valley, documenting Indo-Hispano culture and Mestizo identity. In 1983 he received a Master of Arts from the University of New Mexico. Gandert's photographs have been exhibited at the National Museum of American History at the Smithsonian Museum in 1990, at the Whitney Museum's Biennial in 1993, and at the National Hispanic Cultural Center in 2000. A Distinguished Professor Emeritus at the University of New Mexico, Gandert frequently collaborates with other scholars to explore the history and culture of the Southwest. His publications include *Pilgrimage to Chimayó: Contemporary Portrait of a Living Tradition*, with Sam Howarth and Enrique R. Lamadrid (Museum of New Mexico Press, 1999); *Nuevo México Profundo: Rituals of an Indo-Hispano Homeland*, with Enrique R. Lamadrid (Museum of New Mexico Press, 2000) and *The Plazas of New Mexico*, with Chris Wilson, Stefanos Polyzoides, and Jose Zelaya (Trinity University Press, 2011). The Smithsonian Institution, the Stanford University Library and the Beinecke Library hold extensive collections of Gandert's work.

Karen Halverson (b. 1941)

Born in Syracuse, New York, Halverson received a Bachelor of Arts from Stanford University and Masters of Arts from Brandeis University and Columbia University. In 1975, she made her first photographic series, capturing the energy of New York City's Garment District. Much of her work documents the tension between the natural and cultural landscapes of the American West. Observing that photography is better suited to description than explanation, she aims to draw her viewer's eye into an image, to provoke the mind to ponder what it sees. In *Downstream: Encounters with the Colorado River* (University of California Press, 2008) Halverson retraces the route of John Wesley Powell's expeditions, exploring what Americans have made of that great waterway. Dartmouth College, The Huntington Library and Art Collections, and the Autry National Center have hosted solo exhibitions of Halverson's work. The Huntington Library, Los Angeles County Museum of Art, and the Beinecke Library hold significant collections of her work.

Lauren Henkin (b. 1974)

From Oregon to Alabama, through Charleston, West Virginia, New York City and rural New England, Lauren Henkin's photographs explore Americans' relationships with nature and the tension between preservation and extinction that marks much of American history. Born in Washington, D.C., Henkin grew up in Maryland. She received a Bachelor of Arts in Architecture from Washington University in St. Louis in 1996. After living in Portland, Oregon, and New York City, she now resides in Maine. In 2010 Henkin founded Vela Noche Press, one of several vehicles that have allowed her to explore the relationship between poetry and photography. Henkin has published multiple photobooks including *Displaced* (2010); *Silence is an Orchard* (Vela Noche, 2010); and *Growth* (Vela Noche, 2011). *It Isn't Black and White*, a collaboration with poet Kimiko Hahn will be released in 2018. Henkin's photographs have been collected in depth by Duke University and the Beinecke Library.

Jon Lewis (1938–1969)

Gaylord Jon Lewis was born in Burwell, Nebraska. After serving as a military photographer in the Marine Corps, Lewis completed a bachelor's degree in journalism from San Jose State University. In January 1966 he delayed plans to pursue further studies to join the farm workers' movement led by Larry Itliong, Cesar Chavez, and their associates. Over five years, Lewis made more than 10,000 photographs documenting the efforts of the United Farm Workers' Organizing Committee and the California Grape Strike. He was the only photographer to participate in every day of the UFW's 340-mile march from Delano to Sacramento. In 1967, to support the farm workers, Lewis self-published *La Huelga de la Uva en Delano—The Strike of the Grape in Delano: A Portfolio of Prints from the Huelga*. In 1969, he published his master's thesis in photography at San Francisco State University: *From this Earth . . . of the Delano Grape Strike*. The Beinecke Library acquired Lewis's photographic archive shortly before his death.

Owen Luck (b. 1943)

Owen Luck is an American photographer known for depicting Native American life. In 1973, after serving two tours as a combat medic in Vietnam, Luck traveled to Pine Ridge, South Dakota, to provide medical support during the American Indian Movement's (AIM) liberation of Wounded Knee. He carried a camera and created an extensive record of the confrontation between AIM and the FBI. His account of that experience, "A Witness at Wounded Knee 1973," was published in *The Princeton University Library Chronicle* in 2006. In 1975 Luck documented the Menominee Warrior Society's occupation of the abandoned Alexian Brothers Novitiate in Gresham, Wisconsin. Since 2004 he has worked among indigenous communities of the Pacific Northwest. Luck has donated photographs to Ogallala Lakota College in Pine Ridge, to the Haida Gwaii Museum in Skidegate, and to the Makah Museum in Neah Bay. Significant collections of his work are held by Princeton University Library and the Beinecke Library.

Laura McPhee (b. 1958)

Laura McPhee is currently working in the deserts of the North American West exploring time on geologic and human scales. Using a view camera that holds 8 x 10-inch color film, McPhee creates images that encourage viewers to contemplate the ways we exploit the earth and consider the unintended consequences of our efforts to control and manage nature. Her photographs depict our paradoxical efforts to restore, protect, alter, and use the land. After graduating from Princeton, McPhee received an MFA in Photography from the Rhode Island School of Design. A Professor of Photography at the Massachusetts College of Art and Design since 1986, she has published numerous books including *River of No Return* (Yale, 2008), *Guardians of Solitude* (Iris Editions, 2009) and *The Home and the World: A View of Calcutta* (Yale, 2014). McPhee's photographs have been collected by the Metropolitan Museum of Art, the J. Paul Getty Center Museum, the San Francisco Museum of Modern Art, and the Museum of Fine Arts in Boston. The Beinecke Library holds the complete archive for McPhee's "River of No Return" project.

David Grant Noble (b. 1939)

David Grant Noble grew up in rural Massachusetts. Following his graduation from Yale in 1961, he became a serious photographer while serving in Vietnam. Moving to New York, Noble wrote and photographed for *Manhattan East*. In 1970 he photographed Mohawk steelworkers constructing skyscrapers in midtown; that project led Noble to photograph Chippewa wild rice harvests in Wisconsin and Minnesota. In 1971, he moved to New Mexico where he photographed excavations at Arroyo Hondo pueblo, a fourteenth-century site. Since then, Noble has focused on the Southwest's deep history, traveling widely to photograph ruins, rock art, and landscapes. His publications include *Ancient Ruins of the Southwest* (Northland Press, 1981), now in its fourth edition, *In the Places of the Spirits* (SAR Press, 2010), and eleven books on Southwest archaeology. Noble's photographs have been collected by the Museum of New Mexico, the New York Public Library, and the Beinecke Library.

David Ottenstein (b. 1960)

David Ottenstein has worked as a freelance photographer in New Haven, Connecticut, since 1982. Growing up in State College, Pennsylvania, Ottenstein developed a strong interest in American history and culture which influenced his decision to major in American Studies at Yale; that same interest has shaped his independent documentary photography, which frequently explores the interiors of abandoned and decaying buildings in the Northeast, the vanishing agrarian landscape of the Midwest, and the cultural landscapes of the American West. Ottenstein is particularly concerned with drawing attention to the ways in which the demise of independent, family farmsteads has transformed the architectural and social landscapes of the Midwest, a theme at the heart of his first book, *Iowa: Echoes of a Vanishing Landscape* (Prospecta Press, 2017). The Permanent Collection of Grinnell College, the Nelson-Atkins Museum of Art, and the Beinecke Library hold extensive collections of Ottenstein's work.

David Plowden (b. 1932)

A Bostonian by birth, David Plowden graduated from Yale in 1955 with a degree in economics. He worked briefly for the Great Northern Railway before pursuing a career as a photographer. He studied with Minor White and Nathan Lyons, and assisted O. Winston Link. Since 1952, when he began to photograph steam locomotives, Plowden has studied, documented, and commented upon the transformation of America. Describing himself as "an archeologist with a camera" who has spent his life "one step ahead of the wrecking ball," he has published more than twenty books, including *The Hand of Man on America* (Smithsonian, 1971), *Requiem for Steam: The Railroad Photographs of David Plowden* (Norton, 2010), and *Heartland: The Plains and the Prairie* (Norton, 2013). Plowden's archive is held by the Beinecke Library; significant collections of his photographs are held at the Nelson Atkins Museum of Art, the Smithsonian Institute, and the Art Institute of Chicago.

Roberta Price (b. 1946)

Roberta Price is a writer, photographer, and intellectual property attorney in Albuquerque. Raised in White Plains, New York, Price graduated from Vassar College in 1968 and pursued graduate studies with the literary critic Leslie Fiedler at SUNY Buffalo. In 1969 a SUNY summer grant supported her photography of rural communes in the Southwest. A year later, she moved to Libre, a commune in the Huerfano Valley of Colorado, where she lived and photographed for seven years, creating more than 3,000 images. Those photos provided the illustrative spine for Price's first book, *Huerfano: A Memoir of Life in the Counterculture* (University of Massachusetts, 2004) and are the focus of her second book, *Across the Great Divide: A Photo Chronicle of the Counterculture* (New Mexico, 2010). Price is an officer, board member, and photographer for the New Mexico State Fair Portrait Project. Her photographs of life in the counterculture are preserved at the Beinecke Library.

Kim Stringfellow (b. 1963)

An artist, educator, writer, and independent curator based in Joshua Tree, California, Kim Stringfellow is an Associate Professor at San Diego State University's School of Art + Design. She received an MFA in Art and Technology from the School of the Art Institute of Chicago in 2000. Combining photography with audio, video, interactive mapping, and community participation, Stringfellow has explored the landscapes of Southern California, prodding us to recognize the environmental consequences of the way we use and occupy the land. Her work has been exhibited at the International Center for Photography, Los Angeles County Museum of Art, and The Autry National Center. Her publications include *Greetings from the Salton Sea: Folly and Intervention in the Southern California Landscape, 1905–2005* (Center for American Places, 2005) and *Jackrabbit Homestead: Tracing the Small Tract Act in the Southern California Landscape, 1938–2008* (Center for American Places, 2009). The Beinecke Library, the Comer Collection of Photography at the University of Texas, Dallas, and the University of California Riverside's Culver Center for the Arts hold significant collections of her photographs.

Toba Pato Tucker (b. 1935)

Born in the Bronx, New York, Toba Tucker began her professional career after attending a Harold Feinstein workshop in 1976. Her friend Toby Old helped her master a 120mm Hasselblad that became her principal camera for a quarter century, during which she focused on formal portraiture, especially of Native Americans. From an extensive archive of more than 1,000 portraits, she published three major community studies: *Heber Springs Portraits: Continuity and Change in the World Disfarmer Photographed* (New Mexico, 1996), *Pueblo Artists: Portraits* (Museum of New Mexico Press, 1998), and *Haudenosaunee: Portraits of the Firekeepers, the Onondaga Nation* (Syracuse University Press, 1999). In 2010, after nearly a decade's hiatus, Tucker resumed her photographic career. Adopting a digital camera and shifting from silver gelatin to pigmented ink prints, she began a multi-year project of photographing western landscapes. While the Beinecke Library holds Tucker's archive, her work has been collected by nearly two dozen museums including the Metropolitan Museum of Art, the National Museum of the American Indian, and the Los Angeles County Museum of Art

John Willis (b. 1957)

An artist and educator, John Willis sees photography as a powerful a tool for community development as well as self-expression. A professor at Marlboro College, Willis co-founded the In-Sight Photography Project and its Exposures Cross Cultural Youth Program to teach photography to adolescents regardless of their means. The program brings youth from Vermont, the South Bronx, and the Navajo Nation to Pine Ridge, South Dakota, to make photographs and share stories with Lakota teens. Willis's conviction that community-based learning enhances the ability of artists to develop and share their insights informs his art. *Views from the Reservation* (Center for American Places, 2010) integrates multiple Oglala voices with his photographs to present the complexity of life at Pine Ridge. Other publications include *Recycled Realities* with Tom Young (Center for American Places, 2006). In addition to the Beinecke Library, his work is held at the Corcoran Gallery, Whitney Museum, Tokyo Metropolitan Museum, and the National Museum of the American Indian.

Will Wilson (b. 1969)

A Diné photographer, Will Wilson grew up in the Navajo Nation and studied photography at Oberlin College, from which he received a bachelor's degree in Studio Art and Art History, and the University of New Mexico, from which he received an MFA in Photography. Wilson explores the beautiful but often toxic environment of contemporary reservations. His exhibition, *Auto Immune Response* (National Museum of the American Indian, 2006) investigated the rapid transformation of reservation environments that contribute to physical, social, and cultural dis-ease and suggested responses that enable cultural survival. Wilson has also begun a major project to create a national portrait gallery of Native Americans. *Photo/Synthesis* (Oklahoma, 2017) documents a major exhibition of his portraits at the Fred Jones Museum at the University of Oklahoma. Wilson's work is held at New Mexico Museum of Art, Denver Art Museum, the National Museum of the American Indian, and the Beinecke Library.

Selected Bibliography

This is a select list of publications by and about the photographers featured in *Eye on the West*. It is arranged alphabetically by photographer. Within each group publications are arranged chronologically from earliest to most recent.

Abe Aronow

Dan Richards. "Portraits Plain and Simple. Abe Aronow Tackles a Complex Genre with a Minimum of Fuss." *Popular Photography* 64 (Feb 2000): 74–77.

Ira Latour. "Preserving Photographic History Through Portraits." *Black & White* 45 (Sep 2006): 46–51.

Matthew Daniel Mason. "Guide to the Abraham Aronow Photographs." Beinecke Rare Book & Manuscript Library. http://hdl.handle.net/10079/fa/beinecke.aronow.

Marion Belanger

Everglades: Outside and Within. Chicago: The Center for American Places at Columbia College, 2008.

River. Commissioned by Artspace New Haven. Self-published, 2014.

Rift / Fault. Santa Fe: Radius Books, 2016.

Garden Study. Brooklyn, New York: Roman Nvmerals, 2016.

Outside edge. Brooklyn, New York: Roman Nvmerals, 2016.

Ranch house. Brooklyn, New York: Roman Nvmerals, 2016.

Matthew Daniel Mason. "Guide to the Marion Belanger Photographs." Beinecke Rare Book & Manuscript Library. http://hdl.handle.net/10079/fa/beinecke.belanger.

Matthew Daniel Mason. "Guide to the Marion Belanger Rift/Fault Collection." Beinecke Rare Book & Manuscript Library. http://hdl.handle.net/10079/fa/beinecke.belangerriftfault.

Richard Buswell

Echoes: A Visual Reflection. Helena: Archival Press in association with the Museum of Fine Arts of the University of Montana, 1997.

Silent Frontier: Icons of Montana's Early Settlement: New Photographs. Missoula: Museum of Art & Culture, the University of Montana-Missoula, 2002.

Traces: Montana's Frontier Re-visited: New Photographs. Missoula: University of Montana Press, 2007.

Close to Home: Photographs. Albuquerque: University of New Mexico Press, 2013.

What They Left Behind: Photographs. Albuquerque: University of New Mexico Press, 2017.

Matthew Daniel Mason, "Guide to the Richard S. Buswell Photographs." Beinecke Rare Book & Manuscript Library. http://hdl.handle.net/10079/fa/beinecke.buswell.

Miguel Gandert

Pilgrimage to Chimayó: Contemporary Portrait of a Living Tradition, by Sam Howarth and Enrique R. Lamadrid. Photographs by Miguel A. Gandert. Santa Fe: Museum of New Mexico Press, 1999.

Nuevo México Profundo: Rituals of an Indo-Hispando Homeland. Santa Fe: Museum of New Mexico Press, 2000.

Hermanitos Comanchitos: Indo-Hispano Rituals of Captivity and Redemption, by Enrique R. Lamadrid. Photographs by Miguel A. Gandert. Albuquerque: University of New Mexico Press, 2003.

The Plazas of New Mexico, edited by Chris Wilson and Stefano Polyzoides. Contemporary photographs by Miguel Gandert. San Antonio: Trinity University Press, 2011.

In the Country of Empty Crosses: The Story of a Hispano Family in Catholic New Mexico, by Arturo Madrid. Photographs by Miguel Gandert. San Antonio: Trinity University Press, 2012.

Hotel Mariachi: Urban Space and Cultural Heritage in Los Angeles, essays by Catherine L. Kurland and Enrique R. Lamadrid. Photographs by Miguel A. Gandert. Albuquerque: University of New Mexico Press, 2013.

Matthew Daniel Mason and Danijela True, "Guide to the Miguel Gandert Photographs and Papers." Beinecke Rare Book & Manuscript Library. http://hdl.handle.net/10079/fa/beinecke.gandert.

Karen Halverson

The Great Wide Open: Panoramic Photographs of the American West, by Jennifer A. Watts and Claudia Bohn-Spector. London: Merrell, 2001.

Downstream: Encounters with the Colorado River. Berkeley: University of California Press, 2008.

Both Sides of Sunset, Photographing Los Angeles, edited by Jane Brown and Marla Hamburg Kennedy. New York: Metropolis Books, 2015.

Lauren Henkin. "Women in the Landscape: Karen Halverson." *Tilted Arc.* 2014. http://www.tilted-arc.com/2014/11/11/women-in-the-land-scape-karen-halverson/.

Matthew Daniel Mason, "Guide to the Karen Halverson Collection of Western Photographs." Beinecke Rare Book & Manuscript Library. http://hdl.handle.net/10079/fa/beinecke.halverson.

Lauren Henkin

Displaced. Self-published, 2010.

Silence is an orchard. Portland, Oregon: Vela Noche, 2010.

Growth. Portland, Oregon: Vela Noche, 2011.

Still Standing, Standing Still, with Rory Sparks and Chris Held. Portland, Oregon: Vela Noche, 2012.

This Land is Your Land. Portland, Oregon: Vela Noche, 2013.

Jon Lewis

La Huelga de la Uva en Delano/ The Strike of the Grape in Delano: A Portfolio of Prints from the Huelga. San Francisco: Jon Lewis, 1967.

From this Earth of the Delano Grape Strike. San Francisco: Jon Lewis, 1969.

Matthew Daniel Mason, "Guide to the Jon Lewis Photographs of the United Farm Workers Movement." Beinecke Rare Book & Manuscript Library. http://hdl.handle.net/10079/fa/beinecke.lewisjon.

Owen Luck

"A Witness at Wounded Knee 1973," *The Princeton University Library Chronicle* 67 (Winter, 2006): 330–358.

Matthew Daniel Mason, "Guide to the Owen Luck Photographs of Haida Gwaii." Beinecke Rare Book & Manuscript Library. http://hdl.handle.net/10079/fa/beinecke.luckwpf178.

Laura McPhee

No Ordinary Land, with Virginia Beahan. New York: Aperture Foundation, 1998.

Forces of Change: A New View of Nature. Washington D.C.: Smithsonian Institution and National Geographic Society, 2000.

Girls: Ordinary girls and their Extraordinary Pursuits by Jenny McPhee, Laura McPhee, and Martha McPhee. New York: Random House, 2000.

River of No Return. New Haven and London: Yale University Press, 2008.

Guardians of Solitude. London: Iris Editions Ltd., 2009.

Gateway: Visions for an Urban National Park, edited by Alexander Brash, Jamie Hand and Kate Orff. New York: Princeton Architectural Press, 2011.

The Home and the World: A View of Calcutta. New Haven and London: Yale University Press, 2014.

David Grant Noble

Pueblos, Villages, Forts, and Trails: A Guide to New Mexico's Past. Albuquerque: University of New Mexico Press, 1994.

Ancient Colorado: An Archaeological Perspective. Denver: Colorado Council of Professional Archaeologists, 2000.

In Search of Chaco: New Approaches to an Archaeological Enigma. Santa Fe: School of American Research Press, 2004.

The Mesa Verde World, Explorations in Ancestral Pueblo Archaeology. Santa Fe: School of American Research Press, 2006.

Santa Fe: History of an Ancient City. Santa Fe: School of American Research Press, 2008.

In the Places of the Spirits. Santa Fe: School of American Research, 2010.

Ancient Ruins and Rock Art of the Southwest: An Archaeological Guide. Fourth edition. Lanham, Maryland: Taylor Trade Publishing, 2015.

Matthew Daniel Mason, "Guide to the David Grant Noble Photographs of Southwestern Cultural Landscapes." Beinecke Rare Book & Manuscript Library. http://hdl.handle.net/10079/fa/beinecke.noble.

David Ottenstein

Michael Harvey. "To Look for America." *New Haven Magazine* 17 (Jan 2008): 30–33.

Iowa: Echoes of a Vanishing Landscape. West Haven, Connecticut: Prospecta Press, 2017.

Matthew Daniel Mason. "Guide to the David Ottenstein Photographs of Iowa." Beinecke Rare Book & Manuscript Library. http://hdl.handle.net/10079/fa/beinecke.ottenstein.

David Plowden

The Hand of Man on America. Washington, D.C.: Smithsonian Institution Press, 1971.

Floor of the Sky: The Great Plains. San Francisco: Sierra Club, 1972.

Commonplace. New York: E.P. Dutton & Company, 1974.

Desert and Plain, the Mountains and the River, with Berton Roueche. New York: E.P. Dutton & Company, 1975.

A Sense of Place. New York: W.W. Norton & Company, 1988.

Imprints: David Plowden: A Retrospective. Boston: Little, Brown, 1997.

Bridges: The Spans of North America. Revised edition. New York: W.W. Norton & Company, 2002.

A Handful of Dust: Photographs of Disappearing America. New York: W.W. Norton & Company, 2006.

David Plowden: Vanishing Point: Fifty Years of Photography. New York: W.W. Norton & Company, 2007.

David Plowden's Iowa. Iowa City: Humanities Iowa, 2012.

Heartland: The Plains and the Prairie. New York: W.W. Norton & Company, 2013.

Matthew Daniel Mason and Jennifer V. Garcia, "Guide to the David
 Plowden Photographs and Papers," Beinecke Rare Book & Manu-
 script Library. http://hdl.handle.net/10079/fa/beinecke.plowden.

Roberta Price

Huerfano: A Memoir of Life in the Counterculture. Amherst: University
 of Massachusetts Press, 2004.
Across the Great Divide: A Photo Chronicle of the Counterculture.
 Albuquerque: University of New Mexico Press, 2010.
"Guide to the Roberta Price Photographs and Papers." Beinecke
 Rare Book & Manuscript Library. http://hdl.handle.net/10079/fa/
 beinecke.rprice.

Kim Stringfellow

*Greetings from the Salton Sea: Folly and Intervention in the Southern
 California Landscape, 1905–2005*. Chicago: The Center for
 American Places at Columbia College, 2005.
*Jackrabbit Homestead: Tracing the Small Tract Act in the Southern
 California Landscape, 1938–2008*. Santa Fe: Center for American
 Places, 2009.
Twenty-Six Abandoned Jackrabbit Homesteads. Self-published, 2010.
The Mojave Project Reader. Joshua Tree, California: Kim Stringfellow
 Press, 2017.

Toba Pato Tucker

*Heber Springs Portraits: Continuity and Change in the World Disfarmer
 Photographed*. Albuquerque: University of New Mexico Press, 1996.
Pueblo Artists: Portraits. Santa Fe: Museum of New Mexico Press, 1998.
Haudenosaunee: Portraits of the Firekeepers, the Onondaga Nation.
 Syracuse: Syracuse University Press, 1999.
Matthew Daniel Mason. "Guide to the Toba Pato Tucker Photographs
 and Papers." Beinecke Rare Book & Manuscript Library.
 http://hdl.handle.net/10079/fa/beinecke.tobapatotucker.

John Willis

Recycled Realities, with Tom Young. Santa Fe: Center for American
 Places, 2006.
Views from the Reservation, with an essay by Kent Nerburn and contribu-
 tions from the Oglala Lakota people. Chicago: Center for American
 Places at Columbia College, 2010.
Lucy Lippard. *Undermining: A Wild Ride through Land Use, Politics,
 and Art in the Changing West*. New York: The New Press, 2013.

Will Wilson

"Working in the fields of signification, cultural misappropriation as
 compost for trans-customary Indigenous art practice," in *Cross
 Currents*. Denver: Metropolitan State University of Denver, 2013.
Heather Ahtone and Janet C. Berlo. *Photo/Synthesis*. Norman, Oklahoma:
 Fred Jones Jr. Museum of Art, The University of Oklahoma, 2017.

Acknowledgments

Eye on the West is the result of extensive collaboration. Thirty years ago, Bill Reese and Marni Sandweiss guided a novice curator to appreciate the relationship between photography and the American West. My Yale colleagues Nancy Kuhl, Tim Young, Kevin Repp, Melissa Barton, Jae Rossman, and Molly Dotson helped shape my approach to collecting contemporary photography; Matthew Mason, one of the Beinecke Library's many outstanding archivists, has ensured that our photography collections are well organized and beautifully described, making it possible for students, scholars, and artists to use them efficiently. Marie-France Lemay of the Yale University Library's Conservation Department has been an invaluable guide to understanding how to care for the collections, securing their availability for study decades from now.

Student assistants Courtney Buchkoski, Bethany Mowry, and Eve Romm provided essential research. Meredith Miller, David Driscoll, and Bob Halloran, the Beinecke Library's staff photographers, created many of the digital files used to make this book. Olivia Hilmer, Melina Moe, Kerri Sancomb, Frances Osugi, Dave Hicking, and Maura Carbone gracefully and patiently coordinated the complex work involved in making a physical exhibition, a digital complement, and a book.

The opportunity to work with and learn from each of the photographers whose work appears in this book has been a gift. This book is a small payment toward the tuition they've never charged. Sally Salvesen has sharpened my prose, saving me from numerous infelicities. Designers Anjali Pala and Miko McGinty turned a vague idea into a beautiful book.

Finally, without the time, space, and support that E. C. Schroeder and Nancy Miles provided at work and at home *Eye on the West* would not exist. I am grateful beyond words.

George Miles
May 2018

This catalogue is published in conjunction with the exhibition *Eye on the West: Photography and the Contemporary West,* held at the Beinecke Rare Book & Manuscript Library from September 1 through December 16, 2018.

Distributed by
Yale University Press
PO Box 209040
302 Temple Street
New Haven, CT 06520-9040
www.yalebooks.com/art

47 Bedford Square
London WC1B 3DP
www.yalebooks.co.uk

Library of Congress Control Number: 2018945010
ISBN 978-0-300-23285-1

Designed by Anjali Pala and Miko McGinty
Type set in Fakt Pro
Printed in Italy by Trifolio S.r.l., Verona

Jacket, front: David Plowden, *Union Pacific Railroad Crossing near Clare, Iowa,* 2011.
Jacket, back: Laura McPhee, *Wing of a Great Horned Owl Killed by a Golden Eagle, a Burl, a Log Cabin, and Isobel,* Idaho, 2015.
Frontispiece: David Plowden, *Near Pullman, Washington,* 1973.